Sacred
Buddhist Painting

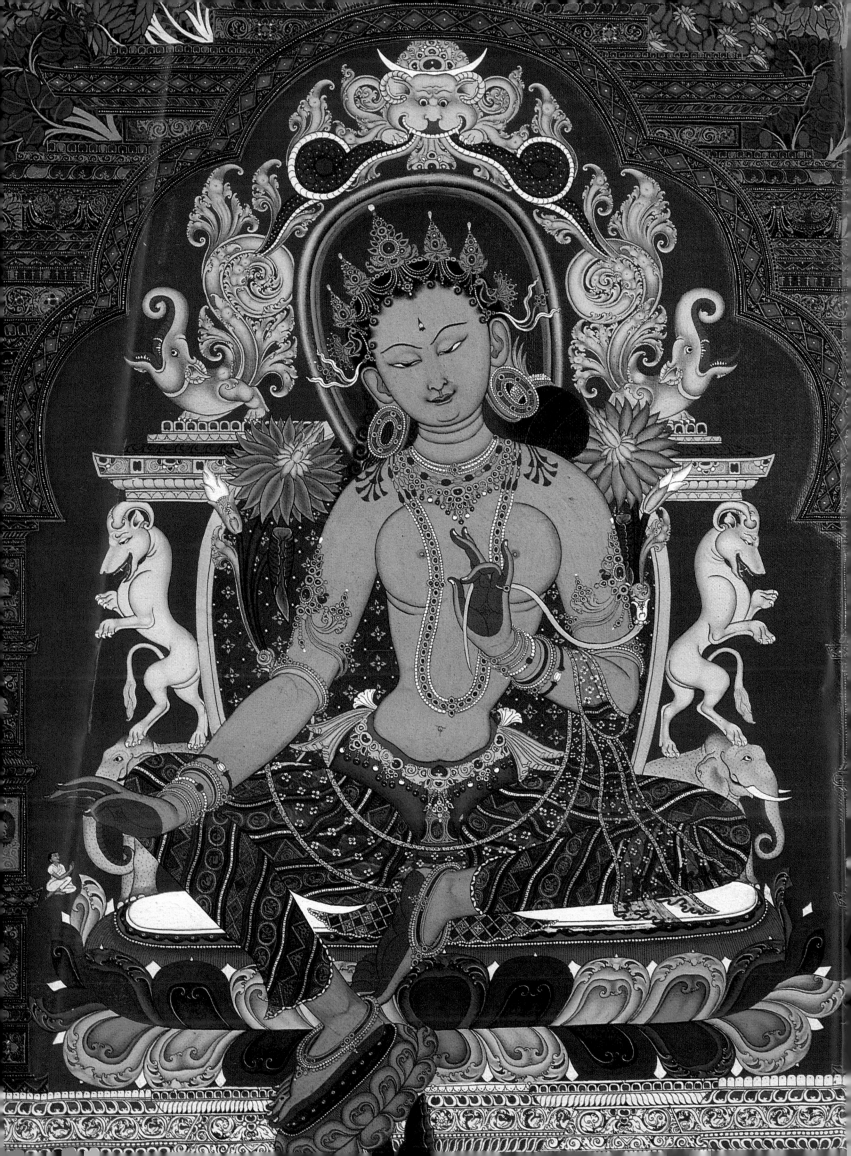

Sacred
Buddhist Painting

Anjan Chakraverty

Foreword
Lokesh Chandra

Lustre Press
Roli Books

ISBN: 81-7436-042-5

For My Parents
—*Anjan Chakraverty*

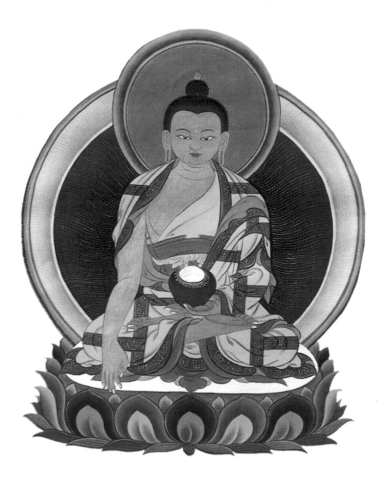

© **Lustre Press Pvt Ltd, 1998**
Third impression 2002

M-75, Greater Kailash-II Market, New Delhi-110 048, INDIA
Phones: 91-11- 6442271, 6462782, 6460886, Fax: 6467185
E-mail: roli@vsnl.com, Website: rolibooks.com

Photographs

Deepak Budhraja: *Thangkas from Dharamsala*
Dheeraj Paul: *Lokesh Chandra Collection*
Thomas L. Kelly: *Thomas. L. Kelly Collections*

Printed and bound at Singapore

Page 2: *Green Tara;* **page 3:** *Samvara
with consort. Thomas L. Kelly Collection.*

Contents

———— ✳ ————

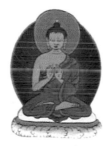
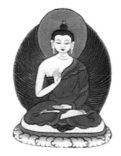

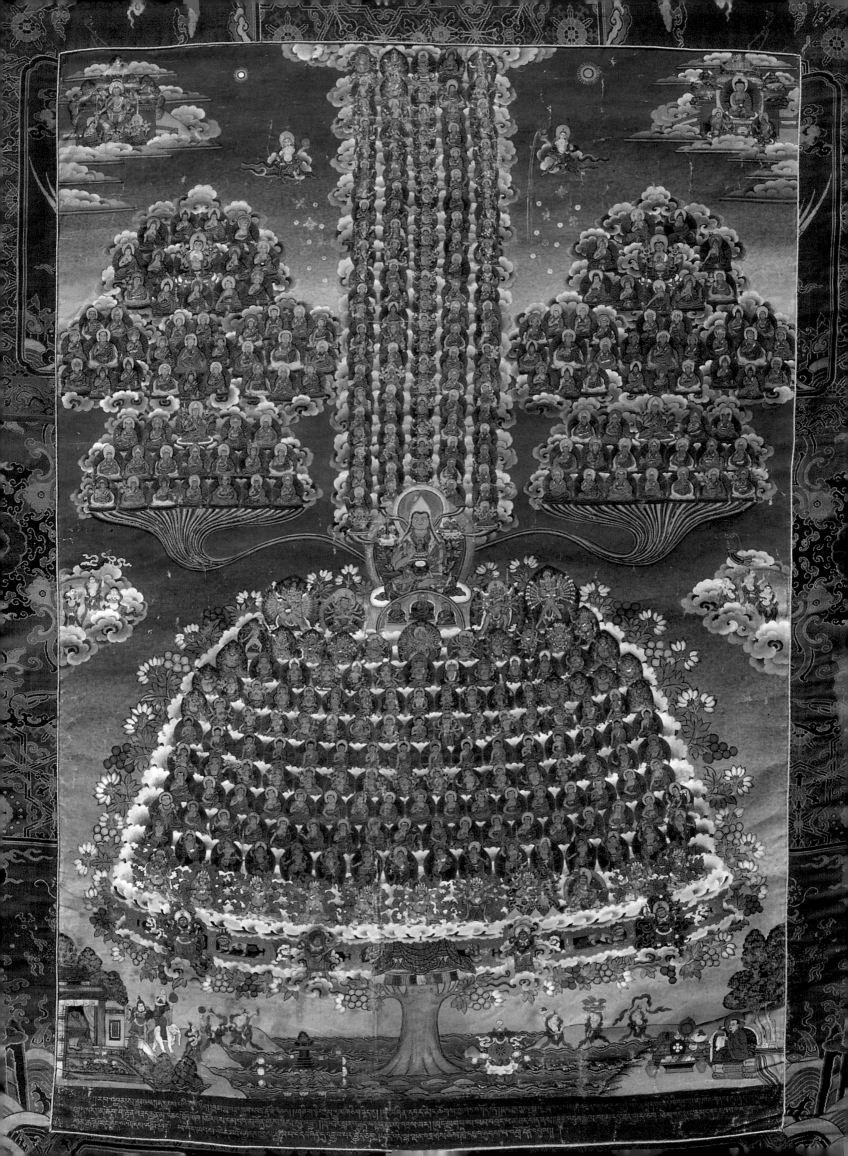

ཇོ་བོ་ཆོས་པ་སྒྲོལ་མ

Foreword

— ✳ —

Tibet is a land of purity and simplicity, open skies and stony wastes, lofty peaks and once-sprawling monasteries sparkling in the sun. It is a soil honey-combed with esoteric revelations, where one sees things from within. It is a continuum of space-silence, the blue silence of the icy peaks, the ochre silence of the rocks, the illusory silence of the temporal world: alas! all enshrined in memory. Tibet awaits sublime centuries, her own, her 'divine territory . . . a land that is a mine of wisdom', as says an inscription. This landscape becomes the awakening of creativity. Divine flashes are painted and sculpted in living icons. The mind gets eyes. The energy of refuge, reverie and repose becomes images and scrolls. All forms are ablaze with valourised realities.

In Tibet, to paint is to evoke. Every painting and sculpture is an evocation. The artist is led to a state of ecstasy through yoga. He sees the images of the deities with the eyes of the spirit. Only one divinised may paint: *nadevo devam archayet*. The artist identifies himself with the supreme, the immutable, the eternal. On the next plane, he imagines in the centre of his being mystic syllables, their sound, the moving force that emanates the symbols evoked, the images of the gods and goddesses. By meditation and ritual the artist projects the infinite. Thereafter the materials are gathered, the rites of purification are performed so that the artist can begin to paint. Iconometry regulates their design. The canons for various deities differ according to their aspects. Manthangpa, the great art theoretician, prescribes eight aspects: monastic (*nirmana-kaya*), royal (*sambhoga-kaya*), those modelled on Samvara with many heads and arms, bodhisattva figures, goddesses of a pleasant appearance, terrific deities, *kinnara* (beings), *shravakas* ('listeners') and *pratyeka-buddhas*. The treatise of Manthangpa has been standard for centuries and it has been law to artistic schools. No transgression is possible, as the thangkas are planes of heavenly bliss, spheres of meditation to which the devotee ascends when turmoil and passion cease.

The substance, the poetic soul, the enjewelled essence of Buddhism is the pictorial solemnity of vision. Form is the way to the sublime. The Tibetan Vinaya enjoins the embellishment of monastic interiors. It is narrated that Anathapindika wanted to decorate the walls of the Jetavana monastery which he was about to offer to Lord Buddha. The monks did not know what to do. Lord Buddha told them that all colours should be employed, a yaksha should be represented at the entrance portal, the Grand Miracle and the Wheel of Existence in the vestibule, the Jatakas in the cloisters . . . and so on. While the painters worked, the monks washed near the frescos, bespattering and splashing at them. They made fire and blackened them with smoke. This earned them a reprimand from the Buddha. When the paintings were completed, people came to admire them and turned to Buddhism. Since the very lifetime of Lord Buddha, paintings have enlivened the march of Buddhism. Buddhism has been Visual Dharma *par excellence*. To consecrate a statue, a scroll, or a sutra has been eternal merit. Streaming flow of lines germinate in inner spaces of being.

In Tibet, deities were either *sku*, 'sacred bodily form', that is, a three-dimensional image, or a *thangka*, 'painting on a flat surface', a two-dimensional representation on a

Facing page: *Gelukpa Assembly Tree with the hierarchy of the Gelukpa Order. Tsong-kha-pa, the founder, is at the centre. Contemporary. Collection: Namgyal Monastery.*

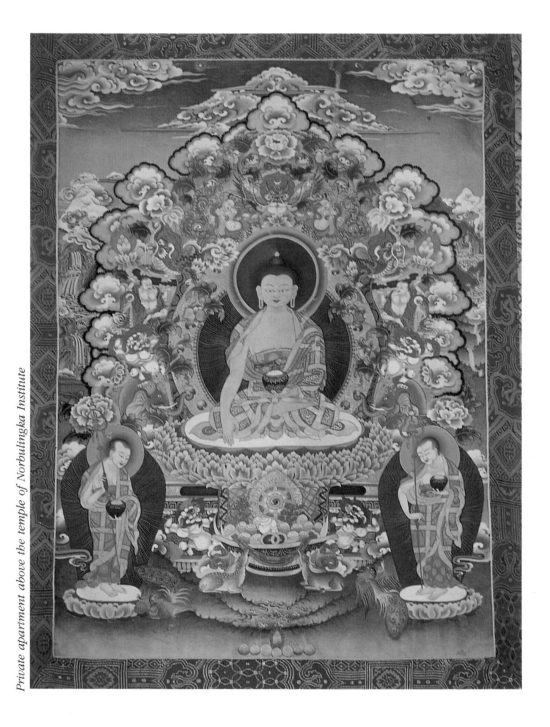

Buddha with his two great disciples Sariputra and Maudgalyayana,
who are famous for their intellectual and mystical powers respectively.
Contemporary. Courtesy: Norbulingka Institute.

scroll or on a wall. Thangka is derived from *thang*, 'a flat plain'. As jewelline luminosities of awakened consciousness, they were done in multiple colours, but at times just in golden outline on a dark background. Scenes from the life of Lord Buddha and of his pre-incarnations in the jataka and avadana stories, have been favourites of Tibetan artists. The Jatakamala of Aryashura and the Avadana-kalpalata of Kshemendra have inspired whole series of scrolls. They show the perenniality of Dharma which had evolved in the mind of the Founder over more than five hundred births. It is the Art of Eternalisation.

The second category of themes is the Art of Interiorisation, wherein various prevalent deities admitted into the Buddhist fold provided a new dimension. Mitra the Sun-God became Maitreya, Indra changed to Vajrapani, and so on. The process of interiorisation of a supreme local deity of light, Lokeshvara-raja can be seen in the evolution of Amitabha/ Amitayus. Amitabha evolved into Rochana, thence into Abhisambodhi Mahavairocana, and further into Vajradhatu Mahavairocana. They form the evolution of phototropic deities of light. Another parallel development was that of erototropic deities of orgiastic cults, like Vajrasattva, Heruka, Samvara, Kalachakra. They were *yab-yum*, or gods in union with their consort goddesses. They became the rich theophany of Tibetan painters and sculptors in the seductive imagination of forms to visualise a beyond. The materialisation of a scroll or a sculpture, of a mural or a mandala, became ineffable ascension.

The traditions of Buddhist art were introduced into Tibet from the eastern parts of India. These classical traditions were continued by Nepalese artists. The Central Asian style of prominent Buddhist centers like Khotan also conditioned the early phase of Tibetan art. The Kashmiri idiom came through western Tibet by the inspiration of Rinchensangpo. It can be seen at Tabo, Alchi and other monasteries and in scrolls of the Guge school. The composite style of the Nyingmapa and Sakyapa irradiated throughout the Land of Snows. With the emergence of the great monasteries of the Gelukpa sect, Tibetan art came into its own. An indigenous idiom emerged wherein the Indian, Central Asian, Nepalese and Chinese contributions flowered into a new national art of Tibet, unique and distinct, with its own flavour and serenity, its own celestial motifs and exuberance of colours. Distinctive Tibetan styles had been formulated by about 1430. Manthangpa, born around this decade, learnt at the great Gomang of Gyantse. He hit upon a new synthesis and founded a new style of painting which has continued down to the present, known as Manri or the style of Manthangpa. He replaced decorative designs of the background by landscapes. He innovated and codified the prevalent practices into a standard compendium. Great masters were ever introducing new sensibilities and substances, as in the Karma Gadri style of Kham in eastern Tibet.

Dr. Anjan Chakraverty presents in this book the rich and varied tradition of Tibetan scroll-painting for the non-specialist. It is a worthy endeavour by a budding scholar of art history and himself a practising artist. It is a welcome book that will carry the message and methodology of Tibet's visual culture to a wide audience. Dr. Chakraverty chronicles the evolution of this art from Lord Buddha's ministry, relates painting practices of Tibetan artists, surveys major styles of painting over the centuries, defines the iconography of outstanding deities and points out the quintessential meaning of these divine configurations. This book is a window to the shining light and essence of being in the shimmering lines and colours of thangkas. It takes the reader beyond the sphere of phenomena to the volume of sky-like emptiness (*shunyata*), painted with colours of pure awareness. Transcendental visions in transient colours:

> *When you see what cannot be seen,*
> *Your mind becomes innately free—reality!*

Lokesh Chandra

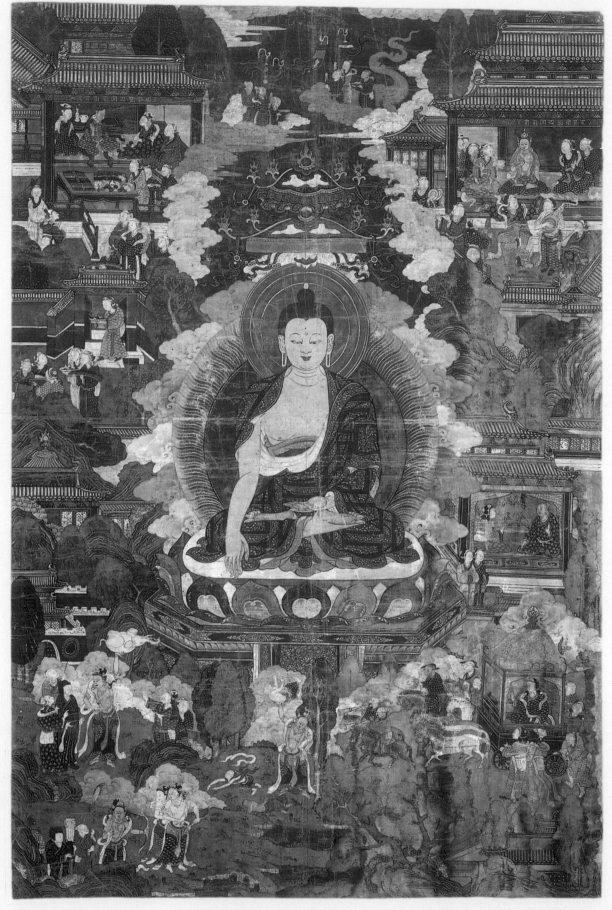

Sakyamuni in earth witness gesture with scenes from his former lives (Jataka). Mid-17th century.

Origin of the Buddha Image

The evolution of Buddhist art and doctrine from its Indian beginnings and the steady spread beyond the geographical limits of Buddhism's homeland picturise an era of great accomplishment. A religious and philosophical message for a passion-ridden laity, Buddhism conquered vast tracks of Asia and eventually became a major world religion. The three cardinal aspects of Buddhism lie in the concept of *triratna* (three jewels) to which a true believer goes for refuge. *Triratna* comprises Buddha (the Enlightened One), Dharma (the Doctrine) and Sangha (the Monastic Order). At its formative stage the cult owed several aspects of its spiritual wisdom to contemporary Indian religious developments. Later, mystical and esoteric ritual practices of Hinduism conditioned much of the metaphysics of the Buddhist creed.

Buddha Sakyamuni must have been venerated if not worshipped during his lifetime. He was deified at a later period and miraculous elements were fused into his historical being for the purpose of edification. Here one must keep in mind that the outstanding non-imitative features of Indian art continued even in its Buddhist application. Born and developed in India the art of Buddhist inspiration has two clearly-defined phases. The first, the Indian period representing Tathagata in symbolic and anthropomorphic form and then as icons born of a complex iconographic system. The second, the extension of Buddhist aesthetics to other parts namely, Mongolia, China, Tibet, Indo-china, Nepal, Japan and Vietnam.

In the Buddhist texts of an earlier date there was no prohibition to the making of anthropomorphic images of the Awakened One. Representation of Buddha by an iconic symbol at the early phase of devotionalism was in many ways a continuation of an older tradition. The bodhi or the Great Wisdom tree became associated with Buddha when he was still living and people made offerings of wreaths and garlands as part of their daily worship. Some of the other symbols which had a definite pre-Buddhist application also became associated iconic representations of the Lord such as the wheel (*chakra*), feet (*paduka*), and trident *(trishula)*.

One of the early cult monuments which symbolised the *Mahaparinirvana* of Buddha was *stupa*, a round solid and domed brick or stone-built structure which enshrined the holy relics. According to legend Buddha himself gave consent to Ananda for the erection of *stupas*. The *stupas* have been classified according to the nature of the relics they enshrine into two classes: *saririka* (those containing relics of 'the body') and *paribhogika* (those containing relics of the things 'of association'). To these two basic types may be included a third sort *uddesika* (prescribed for certain devotional purposes). Emperor Ashoka, whose stone inscriptions are the earliest Indian records of history, extended his imperial patronage to every cause of the *dhamma* (religion). He constructed some 84,000 *stupas* for the Buddha's remains. The texts of Discipline of the Mahasanghikas

*Amitayus or Buddha of Limitless Life seated on a lotus pedestal with a vase of
ambrosia. Thangka commissioned to assure longevity. Late 18th or early 19th century.*

12

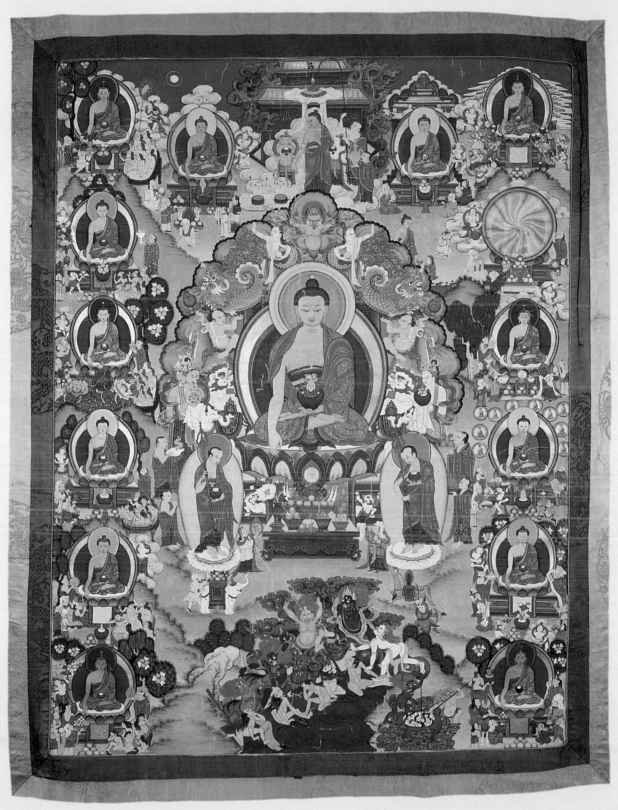

Buddha in earth witness gesture with Sariputra and Maudgalyayana. This centrally placed triad is surrounded by formally arranged depictions of fourteen smaller images of Buddha. Nineteenth century.

13

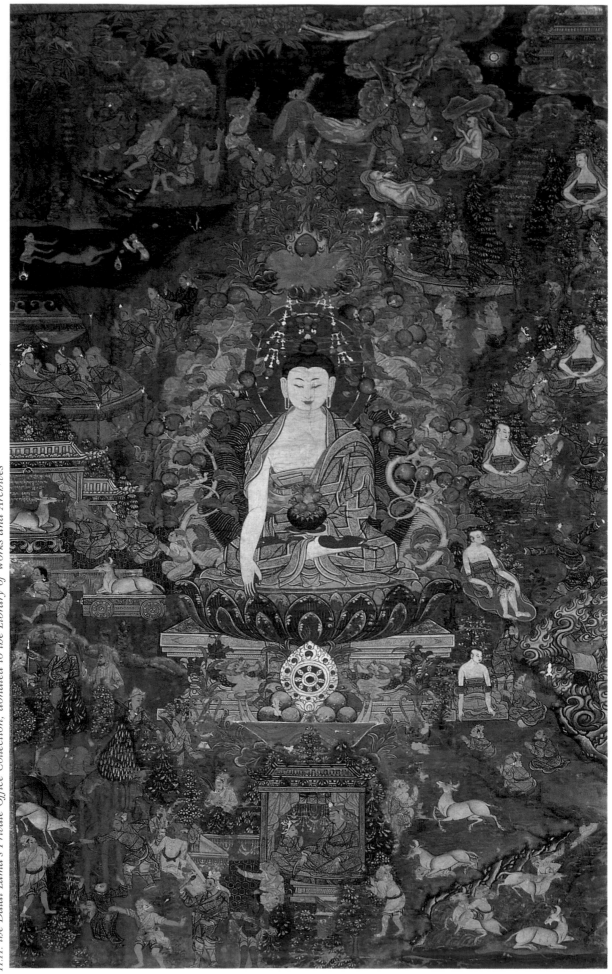

14

allow the decorations of *stupas* and monasteries with paintings of gods, monks, dragons, animals and vegetative motifs but they remain silent on the aspect of the anthropomorphic image of the Buddha.

The passionate devotionalism (*bhakti*) and the efforts of the early Buddhist schools namely, Sarvastivada, a Hinayana sect, and even Mahasanghika to popularise the Buddhist message resulted in the two crucial cult images of Buddha in human form. It is generally held that Sarvastivadins first created the anthropomorphic image of Bodhisattva in keeping with their doctrinal stress on the value of Bodhisattvahood. The artist proceeded to shape the Divine form by drawing upon elements in the world he beheld and then finally consolidated them into the most natural representation of the supernatural.

The beholder of an image must realise that he is seeing the likeness of its transcendental archetype. To create an anthropomorphic image of the Awakened One the artist looked into a vital detail of his biography and picked up the details of thirty-two major and eighty minor marks of virtue and greatness (*mahapurusha lakshana*) with which he was born to become a Buddha or Universal Monarch.

Buddha was represented with the cranial bump (*ushnisa*), with a hairy spiral between the eyebrows (*urna*), with palms and soles marked by wheels and with the fingers of the hands joined as though webbed (*jalanguli*). The earlobes were depicted as being pendulous and a halo was added to enclose the image with divine effulgence.

Parallel to the saga of the origin of the Buddha image in India are the inspired efforts of the Bactrian artists of the Gandhara region on the north-western frontiers of India, to create a Buddha image during the second and first centuries BC. Gandhara (present Peshavar Valley) was at that time ruled by Greeks from Alexander's colony in Bactria (northern Afghanistan). Bodhisattva and Buddha images, standing or seated, in the Greco-Roman tradition with drapery in realistic folds and hair in wavy lines were representations of the ideal human shape. The contemporary Mathura school of sculpture of central India adopted and at the same time influenced the Gandhara Buddha images. Indian Buddhist art found its classical expression in the art of the Gupta era (fourth to sixth century AD). Buddha images carved in stone at the ateliers of Sarnath and Mathura are perfect symbols of the transcendent Buddha engrossed in quiet contemplation. At Ajanta in the rock-hewn caves were painted elaborate narrative panels depicting the Jataka tales (a collection of 550 stories of the former lives of the Buddha), the gospels, the historical life of Buddha and iconographic depictions of the Buddha and the Bodhisattvas. These painted images with their startling linear precision and highly expressive colour schemes influenced not only Indian painting of the post-Ajanta phase but played a vital role as the source reference for the painterly styles of Central Asia, Khoran, Tun-Huang, Himalaya, Nepal and Tibet.

Facing page: *Buddha in earth witness gesture with scenes from Jataka stories. Eighteenth century. The central image of Buddha is surrounded with narrative renderings of* Mriga *(the deer)* Jataka. *The style is linear and the sombre palette has a subdued harmony of tones.*

Buddhism in Tibet and the Lamaist Pantheon

The last bastion of the esoteric cults of Buddhism was destined to be 'the rooftop of the world', in the snow-fenced country called Tibet. This mysterious mountain plateau, which is the birthplace of thangka painting, became a pocket of ancient beliefs, mysticism and supernatural ritual practices. Closed to occidentals, travellers and scholars, till 1894, the culture of Tibet remained unaffected for many centuries. However, early accounts of the peaceful Western travellers were invariably blood-curdling tales of the cruelties they had suffered or of the spellbinding experiences of accomplished mystics.

The introduction of Buddhism into Tibet from India was patronised and conducted by Songsten Gampo who built in Lhasa 'the temple of the Lord'—Jokhang (AD 640). Jowo Sakyamuni, the presiding deity of the shrine is the most sacred image for Tibetan Buddhists down the centuries. Both the consorts of the king, the princess of the Tang dynasty and the daughter of king Anshuvarman of Nepal, were the earliest patrons of the Buddhist religion and were later treated as reincarnations of Goddess Tara in her white and green manifestations respectively. The impulse towards a further development of Buddhism was given by the king's fifth successor Trisong Detsen who under the advice of his Indian Buddhist teacher Shantarakshita invited Padmasambhava, a mystic known for his esoteric miracles. Padmasambhava overcame the priest-magicians of the pre-Buddhist era with his supernatural powers and succeeded in laying the foundation for a systematic development of Buddhism in Tibet. Vajrayana or Tantrayana Buddhism in all its complexities including the belief in numerous Dhyani Buddhas and Bodhisattvas, female personifications of the Supreme Wisdom and many syncretic icons were accepted. Pre-Buddhist gods and the practices of the Bon-po religion were incorporated in a subsidiary manner to increase the popular appeal of the newly-arrived faith.

The root texts of Tibetan Buddhism are *Kanjur* (word of the Buddha) consisting of 108 volumes and *Tanjur* (a collection of extensive commentaries upon the canons by the masters) spread over 250 volumes. *Kanjur* was the compilation of all the available texts of Buddhism in Sanskrit and Pali, copies of which abound in monastic libraries.

The four religious movements of Tibetan Buddhism have been aptly considered by scholars as the 'Four Great Waves' of Buddhism in the windswept land of the mountains. These orders are referred to as Nyingma (the Ancient), Sakya (named after the head monastery), Kagyu (Oral Tradition) and Geluk (Virtue Tradition).

Facing page: Bhaisajyaguru, the Medicine Buddha, is the main Medicine Buddha among a total of eight. He represents a Transcendent (or Cosmic) Buddha's ability to express himself as a healing medicine for the benefit of ailing beings. He is shown here in his characteristic blue colour, holding a bowl of nectar in his left hand and a branch of myrobalan in his right. Contemporary. Collection: Namgyal Monastery.

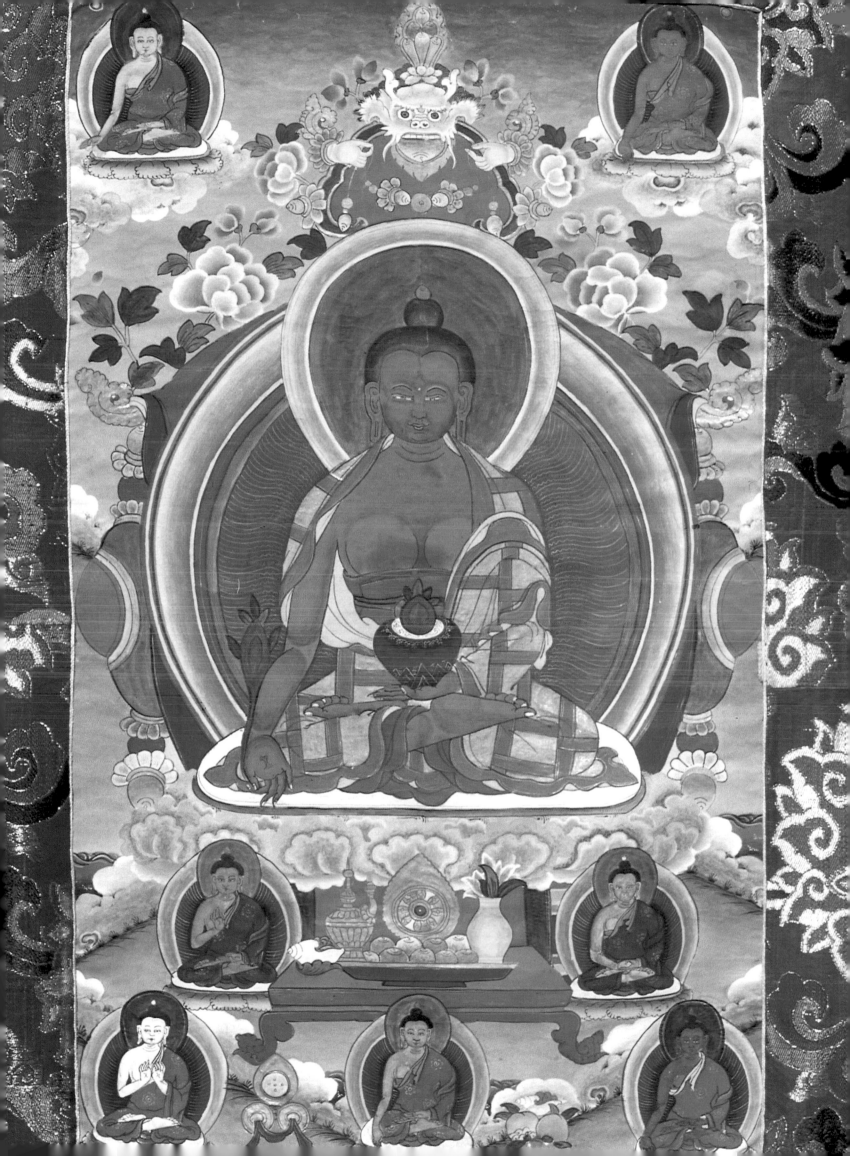

*Amitayus or Buddha of Limitless Life with immortality nectar vase, seated on a lotus.
Late 18th century. This special kind of thangka meant for longevity ceremonies is
painted with gold on a red-ochre background.*

18

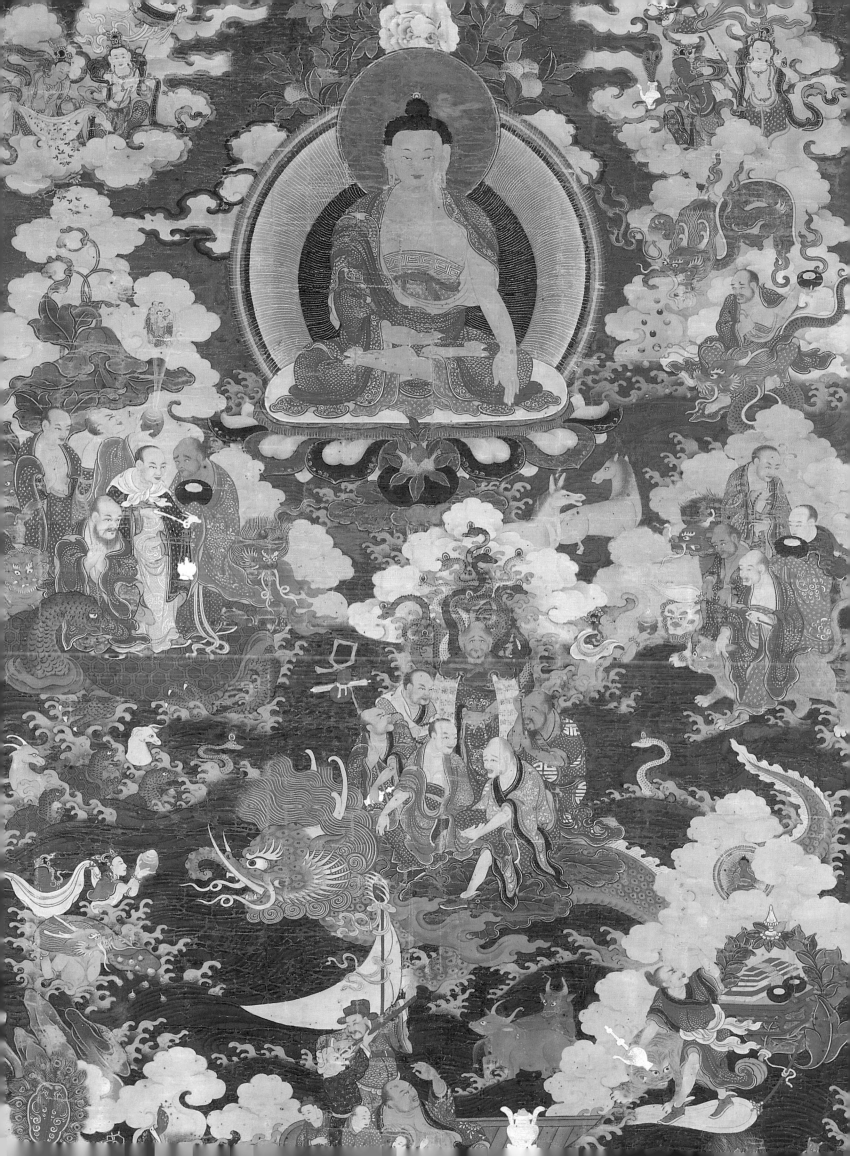

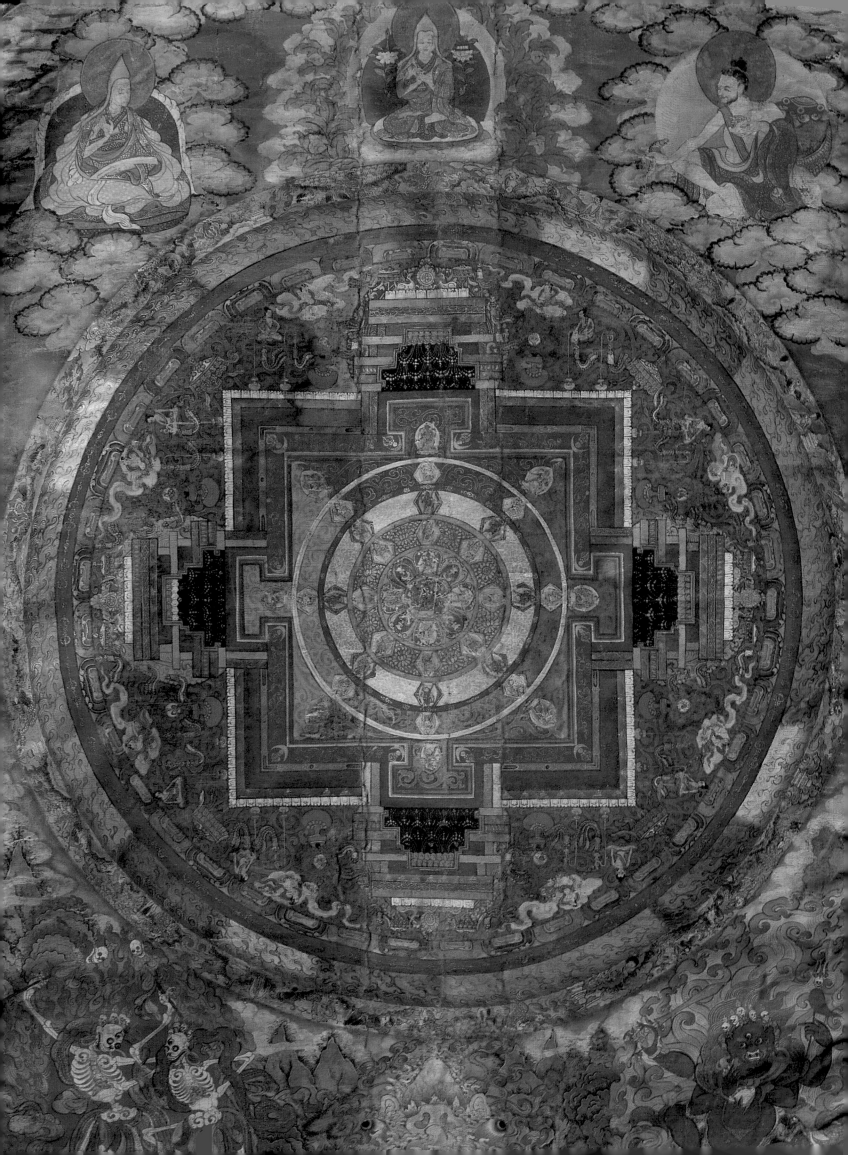

Tibetan Buddhist Iconography
* * *

T he sacred Buddhist paintings of Tibet are mainstays of contemplative invocation for its devotees. The painted images are essentially embodiments of ideas and never idealisation of facts. The height of aesthetic pleasure is touched with divine grace and an artist anticipating the divine form in his mind always remains conscious of the immanent spirit, the inward controller of innate skill. The aesthetic expression that is closely linked to the spiritual quest and in which ritualistic efficacy plays a major role, presupposes the right way of making things. Whatever is appropriate according to the canonical prescriptions of the *Shilpa Shastras* (treatises on the theory and practice of the visual arts) is beautiful in every context of sacredness. Some portions of the *Shilpa Shastras* are contained in the *Tanjur* also. As a result, the operative part of a painting has to be a rational procedure governed by knowledge rather than feeling.

Vajrayana Buddhism, greatly influenced by the polytheistic system of Hinduism, developed an elaborate pantheon realised fully in material imagery. The images are to the Hindu worshipper, what diagrams are to the geometrician. The outstanding non-imitative features of Indian art continued even in its Vajrayana Buddhist application of icon-making. The historical Buddha Sakyamuni, Indian saints, Tibetan saints and divines and even Tibetan kings found a place in the Tibetan Buddhist iconographical formulations. But the true pantheon consisted of major Buddhist deities like Dhyani Buddhas, Bodhisattvas, Taras, Dharmapalas and numerous tutelary deities, some good and harmless and some hostile and terrible. The artists translated the mystical visions of monks and saint-scholars into sculptural or pictorial forms and while doing so faithfully rendered the codified details of a mental image or an apocalypse of the divine. Thus the verbal models became visuals of potential symbolic significance for apparent idolatry.

Elaborate meditative rituals are integral facets of Tibetan Buddhist spiritualism. The complex sequence of meditative visualisations had their original listing in the Sanskrit Buddhist texts of Vajrayana. Such texts were translated into Tibetan with extensive commentaries by the masters. A collection of meditative visualisations, *Sadhanamala* or Garland of *Sadhanas* containing 326 *sadhanas* was written and compiled by several saint-scholars in 1165. The Tibetan *Sadhanmala* occurs in *Tanjur* under the title 'Sadhana-samucchaya'. Deities were described in these texts in great detail. The postures of the body, the hand gestures, the symbolic

Previous page 19: *Sakyamuni and the eighteen Arhats. This minutely finished thangka has a narrative core from the biography of Arhat Hva Shang who lived in the Ming era. In this painting Hva Shang is shown in a small boat in the foreground while the other seventeen Arhats emerge from the ocean riding various mythical aquatic creatures. Eastern Tibet, 18th century. Collection: Los Angeles County Museum of Art.*
Facing page: *Kalachakra Mandala. Late 18th century. Collection: Namgyal Monastery.*

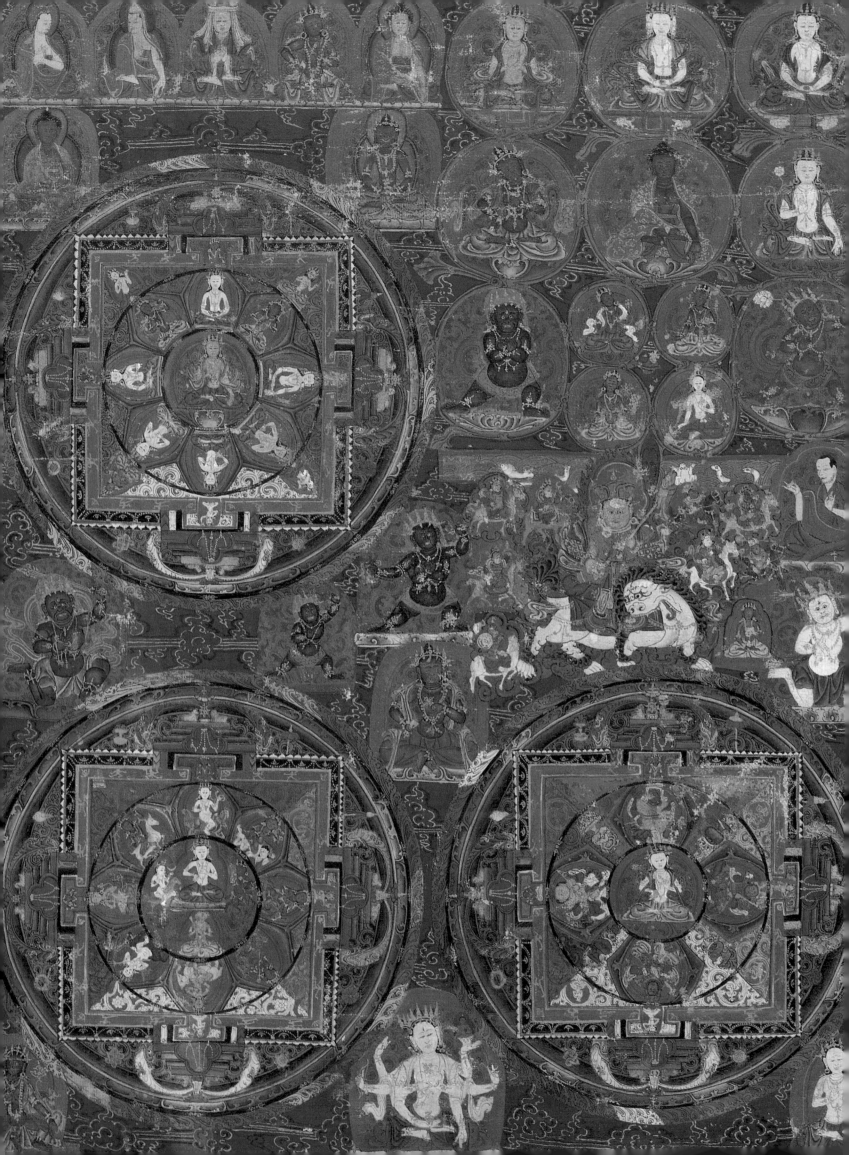

implements, the number of heads or arms, the vehicle, the seat and the colour of the images visualised were documented in detail. Mandalas were also described in the same spirit and they have a definite art-historical significance.

In Tibet, however, there had been no universally accepted system of iconometry for the Buddha image and other deities. The earliest Tibetan texts of iconometry date back to the fifteenth century. Zu-chen (born 1697) a painter-scholar compiled, from both Indian and Tibetan iconometric sources, treatises to reconcile the prevailing differences of opinion regarding the image-making principles. He made a particular reference to *Kalachakra Tantra* (and its commentary the *Vimalaprabha*), *Samvarodaya tantra*, *Krishnayamari tantra* and *Manjushrimulakalpa tantra*. Indian treatises on iconometry were included in *Tanjur* and out of four such texts two important ones are: *Chitralakshana*, a treatise on painting by Nagnajit and *Pratimamanalakshana* ascribed to Atreya. Thus, there existed two types of iconographic manuals, one in which there were descriptions of deities and the other which offered the iconometric lineaments and every minute detail regarding the proportions of the limbs.

The infinitely varied and complex pantheon of Tibetan Buddhism is hard to classify. In addition to the basic Vajrayana deities of Indian origin there were more than five hundred deities of Tibetan conception which were fleshed into the icon family subsequently.

Mahayana and Vajrayana doctrines define the primordial unmanifest void (*shunyata*) as the ultimate. This is symbolised as the thunderbolt or *vajra*. This *sunyata* or womb of all Tathagatas also contains the seed concepts of the 'Three Bodies' (*Trikaya*) of the Buddha. When one attains Enlightenment, the ordinary mind and body is transformed from the physical or manifest dimension into: the Truth Body or *Dharmakaya*, the Beatific Body or *Sambhogakaya* and the Emanation Body or *Nirmanakaya*. The perception of the Truth Body is possible only to the enlightened ones. The Beatific Body, a symbol of universal bliss and an irresistible energy of compassion, is perceivable only to those of exalted wisdom. The Emanation Body is a reflex of the Beatific Body and is present in worldly spheres as incarnational energy.

Although proliferation of the Vajrayana pantheon of Tibetan Buddhism remained steady down the centuries it also preserved the earlier tradition of Sakyamuni Buddha as a historical person. Tibetan versions of his last life based on *Lalitavistara*, a Hinayana biography of Buddha which develops the legendary aspects of his life and accounts of his previous lives derived from the Jataka *Kathas* and *Avadanas* (a Saravastivadin canon of tales of the Buddha and his former lives) were painted in a set of twelve thangkas, each with the Buddha figure in the centre and episodes from his life scattered over the entire background of the painting. The set of the Twelve

Facing page: *Mandalas of Amitayus and Vajrasattva. The inscription on the lower border indicates that this was part of a series of twelve mandalas which were dedicated by Gyaltsen Ozer for 'the cleansing of his sins, those of his father and mother, and all creatures.' Central Tibet—Ngor Sakyapa Monastery, 16th century. Collection: Los Angeles County Museum of Art.*

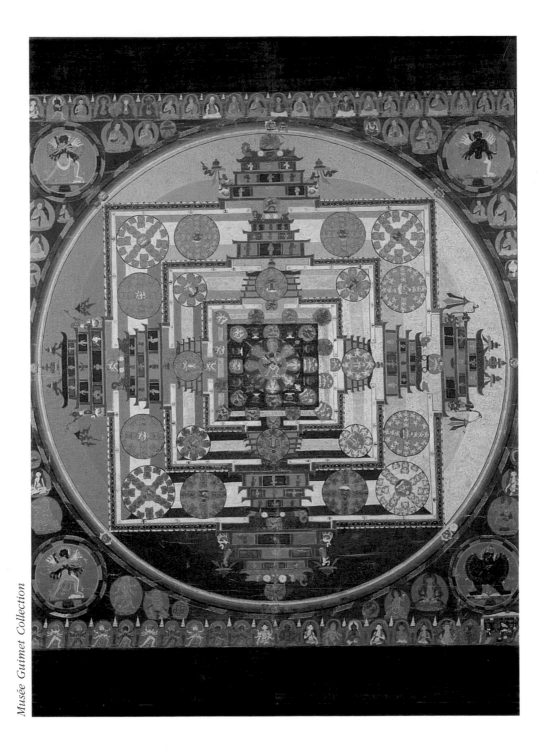

Kalachakra Mandala. Central Tibet, end of the 16th century. The presiding deity of the mandala is Kalachakra who dances in intimate union with his female consort, Vishvamata. There are five enclosures, each studded with deities and having their own triumphal gates.

Acts of Buddha which were popular subjects for the thangka painters may be listed as: (1) his descent from *Tushita*, (2) his entering into the womb, (3) his miraculous birth, (4) his activities as a youth, (5) his exploits with concubines and queens, (6) his renunciation of the worldly life, (7) his intense spiritual application, (8) taking his final seat under the Tree of Enlightenment, (9) his taming of the forces of Mara, (10) his complete Enlightenment, (11) his turning of the Wheel of Law, and (12) his passing away into *Parinirvana*. Such biographical paintings once verbally elucidated left a lasting impact on the worshipper.

The image of Buddha, expressing serene quiescence, is the expression of divine beauty. Thirty-two major and eighty minor signs of greatness and virtue remain always associated with the graciousness of his physical form. The canonical prototype of the Buddha seated in the Vajrasana yoga posture with legs crossed and the soles of the feet visible, continues with relative sameness through the centuries. The golden colour, head protruberance, tuft of hair between the brows, webbed fingers, and long arms are some of the characteristics codified in the *Shilpa Shastras*. Buddha occupies a lotus throne, a symbol of purity. The discs of the sun and moon, symbolising a twin-unity of contrasts form a special seat as may be noted in ancient Tibetan art. The head and the body of a Buddha figure are always enriched by radiant spheres of a nimbus or *prabhavali*, rims of fiery energy. In the painted versions these radiant spheres are enlivened with the colours of the rainbow and often adorned with garlands. Sakyamuni is mostly shown wearing the classical Indian monk's garb with the right shoulder covered by a slip of his gown. His monk's robe or *sanghati* is however, depicted in bright red with a lining of yellow or green and profusely decorated with brocaded patterns in gold. The various *mudras* or symbolic gestures of the hands are meaningful and alter the nature of the images. Among the most common *mudras* are: Abhaya mudra (the right hand raised with palm turned outwards signifying protection); Bhumisparsha mudra (the right hand resting on the right knee and hanging down the middle finger touching the earth signifying the Buddha calling the earth to witness his good deeds when tempted by Mara); Dharmachakra mudra (the hands raised to the breast with fingers indicating the motion of a wheel signifying the First Sermon at Sarnath); Dhyana mudra (hands in the lap with palms turned upwards signifying meditation); Varada mudra (the right hand resting on the knee with palm turned outwards signifying compassion also called the boon granting gesture); and Vitarka mudra (the right hand raised with finger and thumb forming a circle indicating exposition of doctrine).

The cult of the five Cosmic or Celestial Buddhas in Meditation or Dhyani Buddhas originating from the Adi Buddha or the Primordial Buddha began as early as the third century AD and this Mahayana concept served as the basis for Tibetan Buddhist iconography. The state of supra-consciousness reigning the aboriginal void is comprehended as transcendent wisdom and having joined with compassion causes a celestial emanation. Adi Buddha is self-existent and embodies the aboriginal void. Though he is beyond all description and physical form, in the heavenly sphere he

appears as Vajradhara: 'the One who holds the Thunderbolt'. In the iconic form he is represented as a Bodhisattva, dark blue in colour wearing all his ornaments, hands crossed across the breast with sceptre and bell. When depicted with his consort or *sakti*, Prajnaparamita (Transcendent Wisdom) in the *Yab-yum* position, he holds his two implements behind the back of the goddess. The sceptre symbolises the ultimate void while the bell stands for wisdom.

The five Dhyani Buddhas emanate from the Adi Buddha. They are variously identified with the five cosmic elements, five historical Buddhas, five senses, five cardinal points and five virtues. The five Dhyani Buddhas, as they revealed themselves are: Vairochana (the Resplendent One); Akshobhya (Imperturbable); Amitabha (Boundless Light); Ratnasambhava (Jewel Born); and Amoghasiddhi (Perfect Accompaniment). Their emanation is never sequential, all of them manifest at once without any order of first and last. Immersed in deep meditation they are generally depicted in a simple monk's attire but if they have to be portrayed in the celestial sphere with their mystic consorts, they are always crowned and bedecked with jewels.

Other Buddha manifestations of the Tibetan pantheon include a series of Buddhas in time; the thirty-five Buddhas of the Forgiveness of Sins; the eight Medicine Buddhas with Buddha Sakyamuni as Bhaishajyaguru presiding; and Amitayus (Infinite Life), the Buddha of longevity. There are also wrathful aspects of Buddha conceived as Kalachakra, Hevajra, Guhyasamaja, Samvara and Heruka. Interestingly, these names are the titles of the major tantric texts of Vajrayana and since the texts symbolise the speech of the Master they were deified. Even some of the goddesses were actually sacred texts deified in the course of time.

The concept of a Bodhisattva, (an enlightened being who renounces Buddhahood because of his all embracing compassion for all living creatures who require his help), was developed into the iconisation of an entire pantheon of many celestial Bodhisattvas. As the patron saint of Tibet, Bodhisattva Avalokiteshvara (*Chenrezi*) appears in many forms. The most popular Four-armed manifestation as *Chenrezi Chazhipa* inspired numerous painted and three-dimensional representations. The lotus is his seat and he holds a rosary and the lotus flower in his two upper hands (which earned him the appellation Padmapani, the lotus-holding one) while the lower ones are folded together in the Anjali mudra. According to the Tibetan text *Mani-Kambum*, Dhyani Buddha Amitabha caused a white ray of light to emit from his right eye which brought Padmapani Bodhisattva Avalokiteshvara into existence. Blessed by Amitabha he prayed thus: '*Om Mani Padme Hum*' (The Jewel is in the Lotus). The supreme manifestation of this archangel of compassion is the Eleven-Headed One with a thousand

Following page 28: Eleven-faced, thousand-armed Avalokiteshvara. Contemporary. Collection: Namgyal Monastery. The thousand arms of Avalokiteshvara, each set with an eye, are spread in all directions to drive away the suffering of all creatures. This manifestation of Avalokiteshvara is an incarnation of inconceivable mercy.
Page 29: Ushnishatatapattara. Namgyal deity, female counterpart of Avalokiteshvara. Contemporary. Collection: Namgyal Monastery.

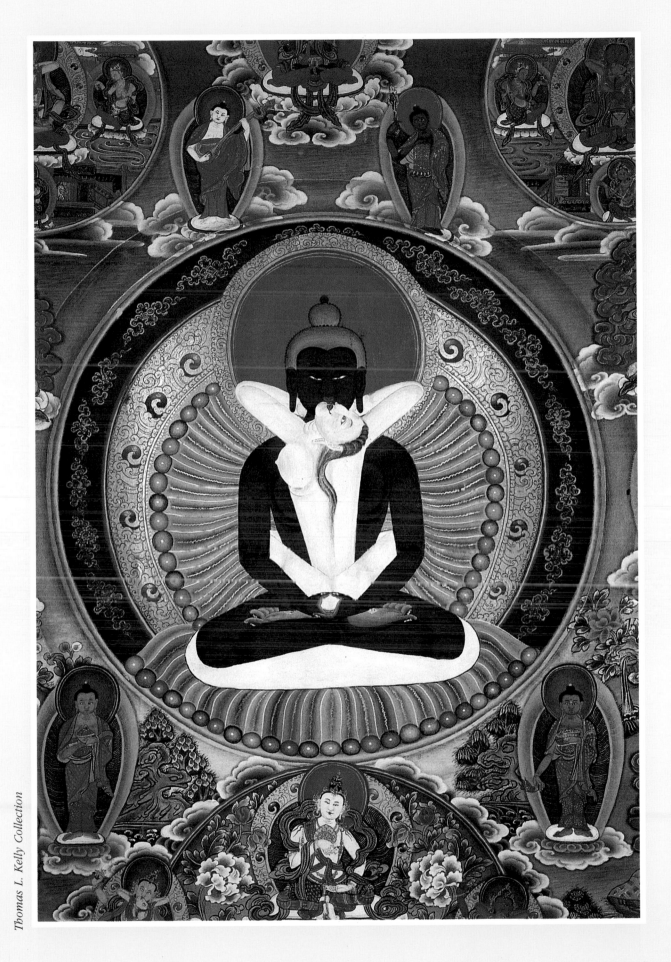

Adi Buddha Samantabhadra with consort. Late 19th century.

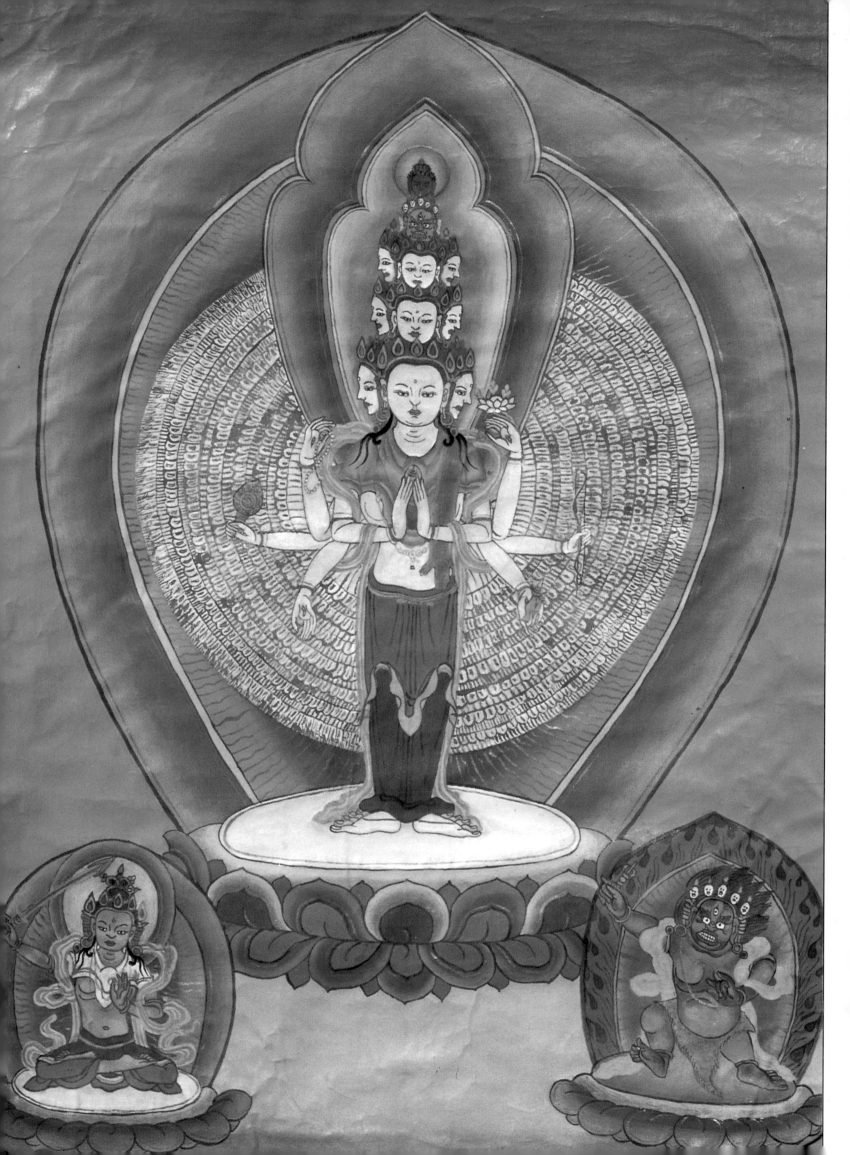

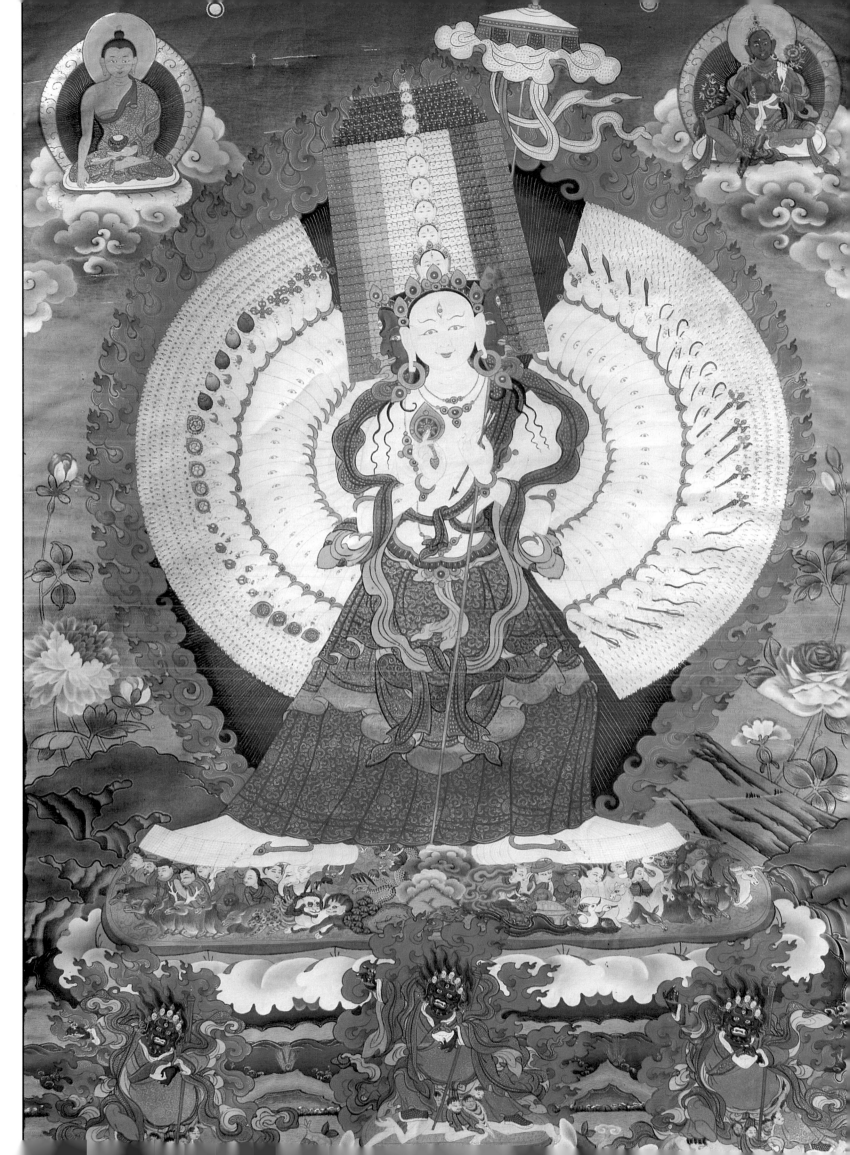

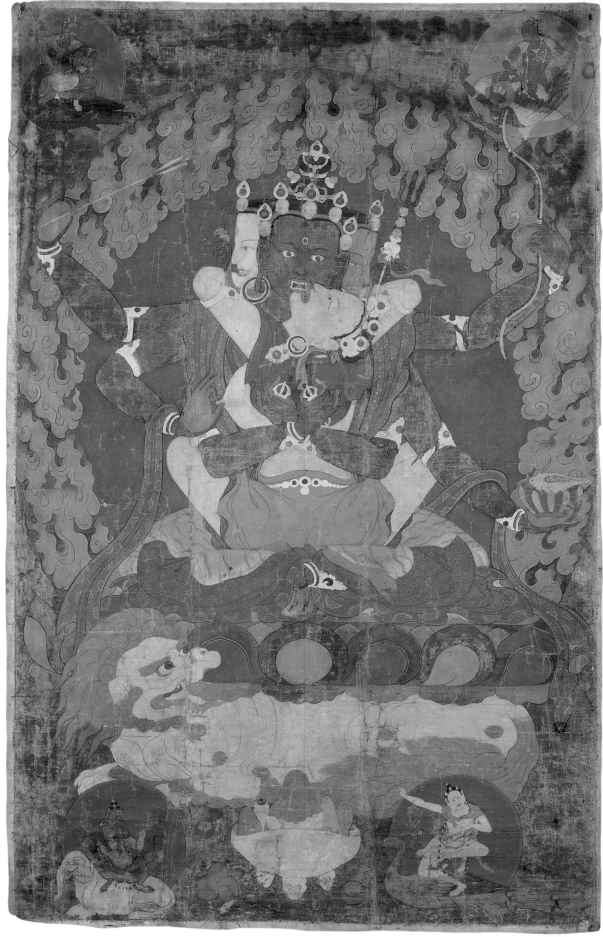

30 *Adi Buddha Vajradhara with his prajna. Central Tibet. Seventeenth century.*

arms. Eight arms grow from his shoulders and he is further surrounded by an inner circle of forty and outer circle of exactly nine-hundred and fifty-two arms very much like rays emanating from the body. His first two hands hold together the wish-granting gem while the remaining six hold a rosary, a wheel, a white lotus in full bloom, a bow and an arrow, a vase containing the elixir of immortality and one hand reaches out in the boon-granting gesture. Similarly, the remaining nine-hundred ninety-two arms hold their respective symbols or make special gestures. In each palm opens the 'eye of Mercy' to help beings overcome the sufferings of *samsara* or their 'egocentric existence'. *Sadhanamala* offers a list of fifteen various forms of Avalokiteshvara. Later traditions reveal one hundred and eight iconographic forms under different aspects such as tranquil, wrathful or fierce.

All the five Dhyani Buddhas have their corresponding Bodhisattva manifestations. Vairochana caused the emanation of Samantabhadra, Akshobhya that of Vajrapani, Ratnasambhava that of Ratnapani, Amitabha that of Padmapani Avalokiteshvara and Amogasiddhi that of Vishvapani. The two other Bodhisattvas widely represented in India, China, Tibet and Japan are Bodhisattva Maitreya and Bodhisattva Manjushri. Maitreya (The Benevolent One), the Buddha of the future, is still in the *Tushita* heaven. He will incarnate himself as Buddha, five thousand years after the death of Sakyamuni Gautam, when Amoghasiddhi, the fifth Dhyani Buddha will create the world. In Tibet he is represented both as Buddha and Bodhisattva. As Buddha he wears a monastic garb, his hands gesturing the Dharmachakra mudra. As Bodhisattva he is depicted as a prince wearing ornaments and a *stupa*-shaped crown. An *ajina* (deer-skin) drapes his left shoulder. He holds a vase in one of his hands while the other is fashioned in the preaching gesture.

Bodhisattva Manjushri or the Bodhisattva of wisdom is mentioned in the Buddhist texts *Guhyasamaja Tantra* and *Manjushrimulakalpa*. He is usually depicted holding the text of Transcendent Wisdom (*Prajnaparmita*) and the double-edged sword of analytic discrimination, which cuts through all delusions and evils of egotism.

An important group of tutelary deities known as Dharmapalas or Protectors of the Doctrine is characterised by intriguing iconographic features. Every religious order, monastery and temple has a protective deity. Most of them appear in wrathful aspects with many arms and heads; some of them having animal heads. They are always adorned with ornaments, jewels, tiger skins, snakes, garlands of flowers and often with garlands of bones and skulls. They may be broadly classified into two categories namely, 'gods of this world' and 'gods of the world beyond'. These deities are chosen by an individual for spiritual guidance and personal protection. They are nearly always depicted with their consorts and as Ishtadevas (personally chosen protective deities) who are worshipped with rituals.

Hevajra, Chakra-Samvara, Kalachakra and Mahakala are some of the cardinal protective deities portrayed in painting and sculpture. Hevajra is usually in a dancing attitude, with four legs, eight heads and sixteen arms. His body is blue and the heads have different colours. *Hevajra Tantra*, the cardinal text of the Sakya order, is believed to be a compilation of his

teachings. He is always shown in mystic union with his female aspect, Vajravarahi, symbolising the blissful union of compassion and wisdom. He has four faces of different colours, each wearing a crown of skulls. These heads have a third eye and a ferocious expression with red-rimed eyes. He has twelve arms, two of them hold the thunderbolt and the bell, two are in *vajra-hum-kara mudra*, two hold an elephant skin, the others a head of Brahma and tantric symbols. He is blue in colour and his consort is red.

Kalachakra is the deification of one of the divisions of the Tibetan *Kanjur*. He is almost always depicted as the presiding image of his mandala and rarely represented alone, that too only on temple banners. This blue bodied deity has four faces and twenty-four arms. In an ecstatic posture of dance he embraces his orange-hued female consort, Vishvamata. He holds various tantric symbols in his hands and tramples over demons.

Mahakala, 'the Great Black One', is the destructive form of the Hindu god Shiva as Bhairava. He was accepted as one of the prominent Dharmapalas around the tenth century and there grew many legends associated with his different forms which are as many as seventy-five. He figures as an archetype deity in his own *Mahakala Tantra* and his every iconographic detail is listed in *Sadhanamala*. In Tibet, Mahakala is always depicted in a peculiar posture with knees bent, as if about to rise from a lotus base. This black-hued deity is plump and dwarfish. His terribly fierce mask-like face remains encircled by a crown of flying hair. He wears animal skin and a garland of skulls and snakes. With his two main hands he holds a chopper and a skullcup; across his arms rests a staff crowned with a severed head, a feature particular to Tibetan representations. An aureole of fierce flames enhanced by gusts of wind stands for the cremation ground, his habitat.

Other wrathful defenders and protectors are Hayagriva: the Horse-Necked One, Yamantaka: the Destroyer of the Lord of Death, and Raktayamari: the Red Enemy of Yama (the Hindu God of Death). Hayagriva, the patron deity of horse traders, shares apparent features with the Bhairava aspect of Shiva, particularly an angry face with a third eye, tiger skin, elephant hide and garland of skulls. Yamantaka is an important deity of the Gelukpa order, a terrifying form of Bodhisattva Manjushri. A cluster of nine heads with a predominant one of a buffalo, sixteen legs and thirty arms manifest him as the terminator of death. Vajrabhairava Yamantaka, the Diamond Terrifier, combines aspects of Yama and Shiva which has developed into a cult of great importance. Raktayamari, another form of Manjushri, is always shown clasping Vajravetali (Diamond Zombie), his wisdom consort. Both deities trample over Yama. The most important of the female defenders of Tibetan Buddhism is Sridevi, the Glorious Goddess whose celestial and tantric manifestations contrast sharply.

The two supreme goddesses of Buddhism are Prajnaparamita and Tara. Prajnaparamita is always depicted enthroned on a lotus seat with hands in the teaching gesture. The lotus flowers issuing forth from her shoulders carry the books of Transcendental Wisdom, *Prajnaparamita Sutras*—the verbal expressions of her wisdom. She is venerated as the Mother of all Buddhas. The Mahayana text *Tara Tantra* says that Vairochana Buddha

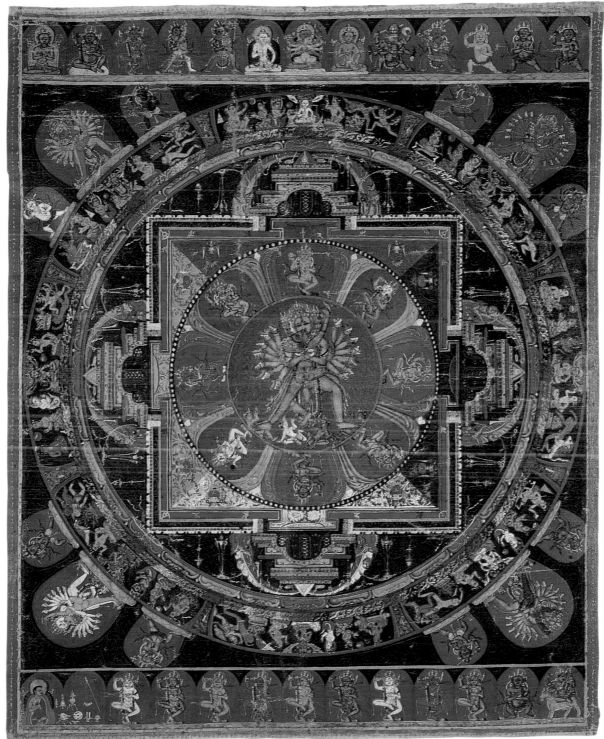

Guhyasamaja with consort Sparshavajra of the same colour in his mandala. Central Tibet, Sakya Monastery. Fifteenth century.

33

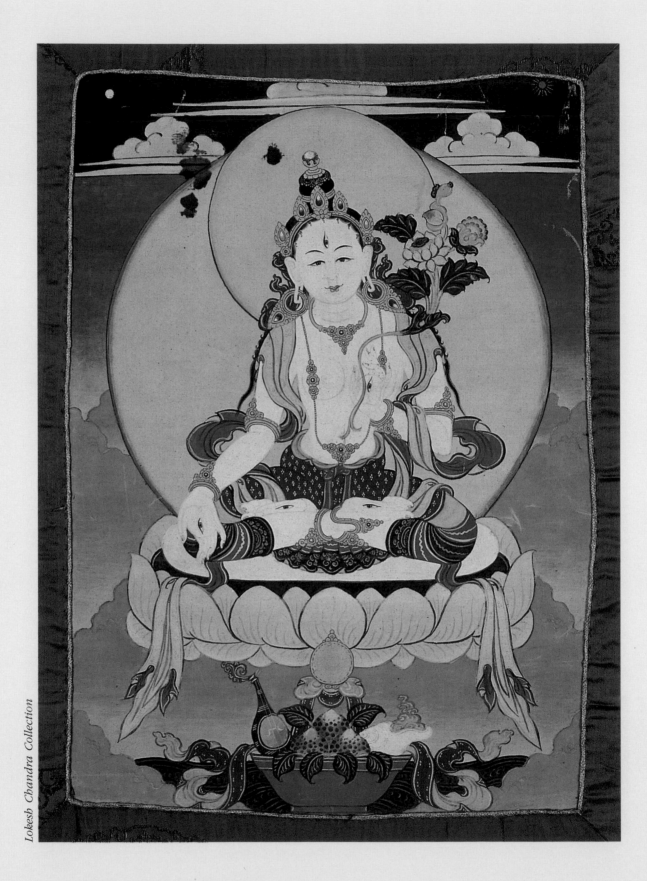

White Tara. Late 19th century. Seated on a white lotus the deity toys with a lotus stalk; in front of her is a bowl full of auspicious articles including a vina *or a lute.*

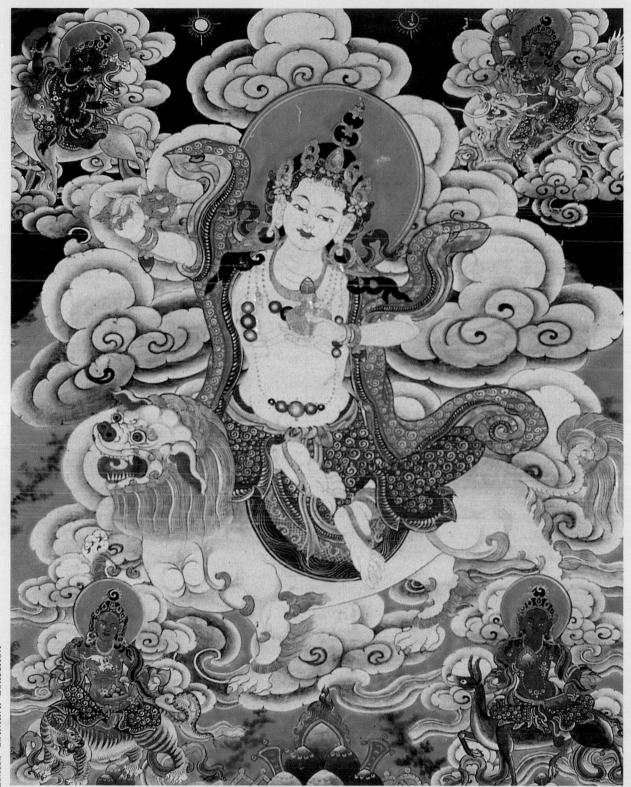

Five goddesses of long life with Mangala, the goddess of auspisciousness, at the centre riding a snow lion. Nineteenth century.

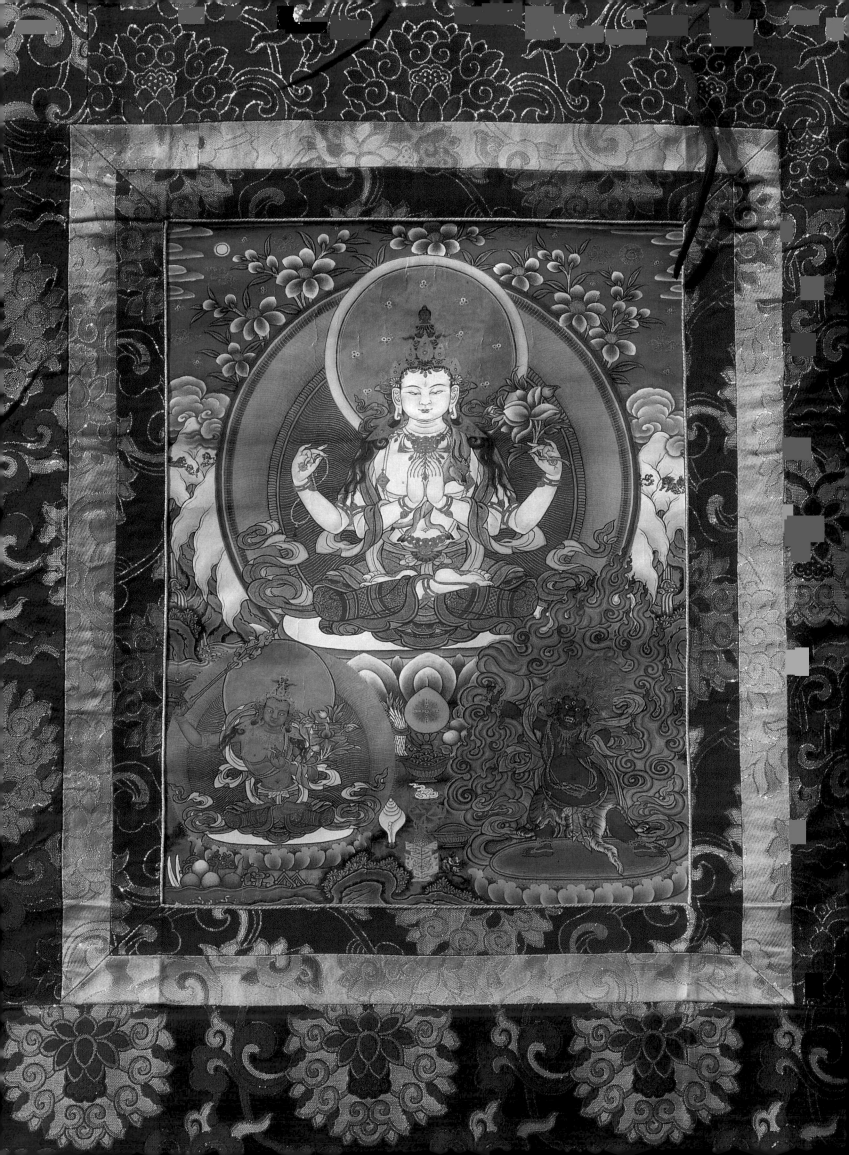

invoked twenty-one manifestations of Tara. Veneration of the feminine principle in Mahayana Buddhism was not introduced before the sixth century AD. Many legends sprang up around the goddess. According to one, from the tears of the Bodhisattva of compassion, Avalokiteshvara, were born: a peaceful White Tara (Shveta Tara) from the left eye and a fierce Green Tara (Shyama Tara) from the right eye. Tibetan legendary sources say the two pious and virtuous wives of King Songsten Gampo came to be considered as incarnations of Tara. Tang Dynasty princess Wencheng was deified as White Tara while the Nepalese princess, Tsezun or Bhrikuti, the daughter of Anshuvarman, was associated with Green Tara. The word Tara is derived from the root 'tri' (to cross), hence the implied meaning: 'the One who enables living beings to cross the Ocean of Existence and Suffering'. White Tara holds a full blown lotus symbolising day. Her right hand is always in the boon-giving gesture and she sits cross-legged, dressed majestically. Green Tara, the companion of Dhyani Buddha Amoghasiddhi, is portrayed seated in *ardha-paryankasana* (one leg bent on the seat and the second pendant or resting on the ground). The right hand is in the boon-giving gesture while the left toys with the slender stalk of a half-open blue lotus. Atisha, a scholar who hailed from eastern India, made Tara his protectoress. She used to appear in his dreams and visions and even persuaded him to accept an invitation to visit Tibet and promulgate the Mahayana doctrine there.

Lokapalas or the Guardian Kings guard the four cardinal points. Among them Vaishravana is the guardian of the north having wealth-bestowing powers. He sits on a lion (invariably a red-maned snow lion) and carries a victory banner in his left hand. Jambhala or the God of Wealth appears in twelve different forms and even in *yab-yum* with his consort. He usually sits on a lotus throne and holds a trident or battle axe and a jewel-spitting mongoose.

Apart from these gods and goddesses of Mahayana origin there are innumerable deities of indigenous origin. The primordial bird Garuda is always painted or drawn with mighty wings holding a snake in its beak. The word *dakini* literally means 'sky-walking woman'. Dakinis, represented always with animal heads, played a very important role in the lives of the Mahasiddhas (Buddhist monks of near-miraculous powers who worked towards spreading the Doctrine). These *dakinis* or cloud-fairies help people to overcome spiritual obstacles. Nagarajas, Serpent Gods of the Waters and the Underworld, harmful if angered, are never missing in any iconographic listing. Their portrayal in painted banners are always as subsidiary demi-gods.

Arhats, Mahasiddhas and Great Sages

Descriptive invocations were thought necessary even for the portrayal of historical figures in order to standardise their precise representation in sculpture and painting.

Facing page: Buddha Akshobhya, one of the Five Transcendent Buddhas, helps in overcoming the affliction of anger. Contemporary. Collection: Namgyal Monastery.

Arhats or the 'Worthy Ones' were the direct disciples of Buddha Sakyamuni and having attained freedom from the cycle of suffering and rebirth promulgated the sacred teachings in every direction. Some texts give a list of fifty *arhats* who accompanied the Buddha, while others mention five hundred, but only sixteen of them are worshipped along with their two attendants. Depictions of these *arhats* with their mystical biographical narratives in thangkas are numerous and they show the transformation of facts into metaphorical statement. Tibetan art has produced some of the most striking depictions of the *arhat* theme in Asian art. The six famous Gurus of Mahayana Buddhism are also known as the 'six crowns of Indian wisdom'. They are Nagarjuna, Aryadeva, Asanga, Vasubandhu, Dignaga and Dharmakirti. In the same vain, eighty-four Mahasiddhas of Indian or Tibetan origin who played a major role in transmitting the Doctrine were mostly represented in a seated or standing posture, and rarely ever in dynamic poses.

Padmasambhava, 'the lotus Born', was invited to facilitate the early promulgation of Buddhism by conquering the heathen shamanic tradition of the Bon-po, the followers of the ancient Bon religion of Tibet. He miraculously disappeared after spending fifty years in Tibet and was subsequently deified. He is generally represented seated in the cross-legged posture, holding a thunderbolt and a begging bowl. His distinctive implement is the *khatvanga* (the magic staff) resting against his breast. His robe and cap are red. In thangkas he is very often depicted accompanied by his two wives, Bengali princess Mandarava and Tibetan queen turned *yogini*, Yeshe Tsogyal. At times his central image in a thangka is surrounded by twenty-five disciples or with scenes from his fabled life.

Spiritual teachers belonging to the initial phase when Buddhism was introduced were followed by the Atisha and Tibetan Gurus of the second epoch in the spread of Buddhism in Tibet and are portrayed as idealised images. There are many such noble personages amongst whom the 16th century monk-scholar and teacher Sonam Gyatso is worth noting. Sonam Gyatso, known for his zeal in converting the Mongols, was given the title Dalai Lama (Dalai: Ocean of Wisdom) by Mongol leader Altan Khan. Some of the other great Dalai Lamas are also included in the great eighteenth century treatise on iconography entitled *Three Hundred Icons*.

The painted images as objects of worship must comply with the regulations of iconography and descriptive invocations of deities. As *dhyeya pratimas* or meditative tools they have to be accurate in every aspect and any ill-proportioned or badly executed image will inspire no faith or devotional zeal. No blessing is acquired from worshipping such icons and the maker of the image accumulates only demerits for his faulty workmanship.

Following page 40: *Tsen deity, regarded as the incarnation of Amitabha, one of the Five Transcendent Buddhas. Contemporary. Collection: Namgyal Monastery.*
Page 41: *Yama Dharmaraja, King of Law. This buffalo-headed Lord of Death of Indian mythology becomes the protector of Dharma in Buddhism, and seeks to protect practitioners and monasteries from drought, bandits and other misfortunes. Contemporary. Collection: Namgyal Monastery.*

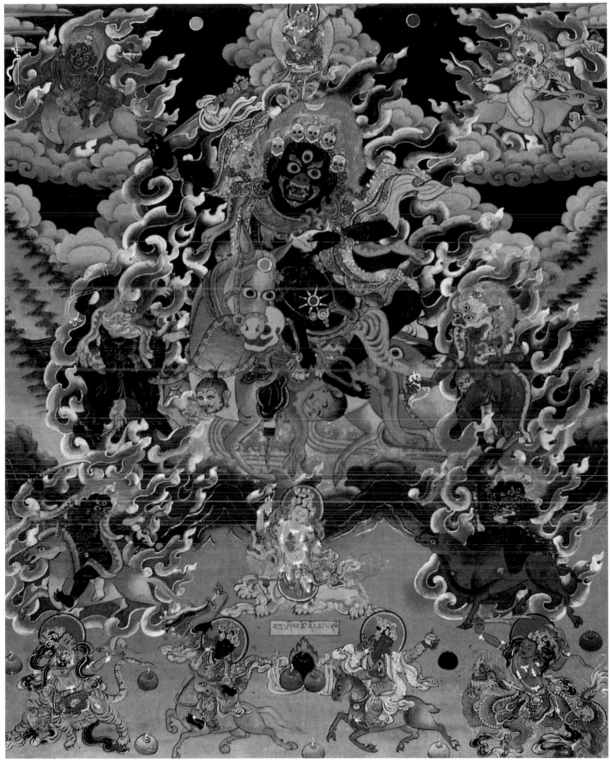

*Palden Lhamo is one of the major protector deities in Tibetan Buddhism and the only
female among the powerful group of Eight Dharma Protectors (Dharmapalas). She is
particularly favoured by the Gelukpa, for whom she is a special protector of
Lhasa and the Dalai Lama. Nineteenth century.*

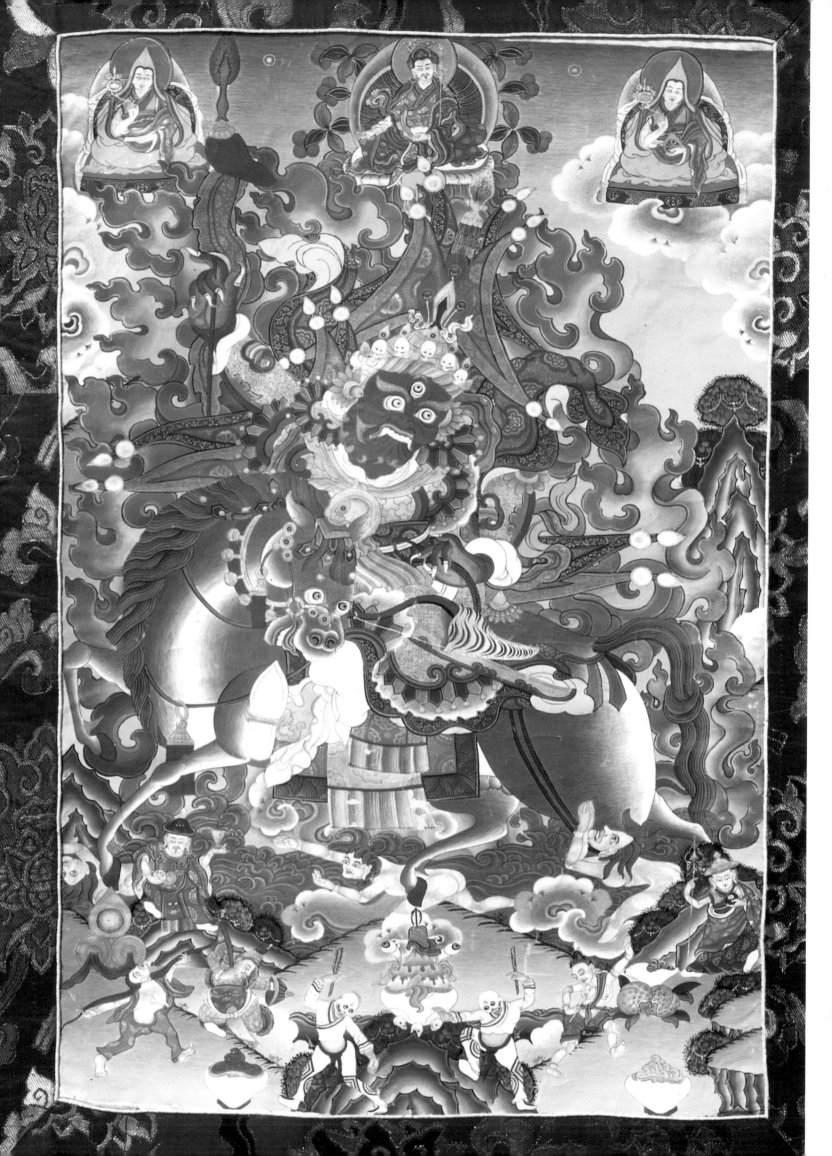

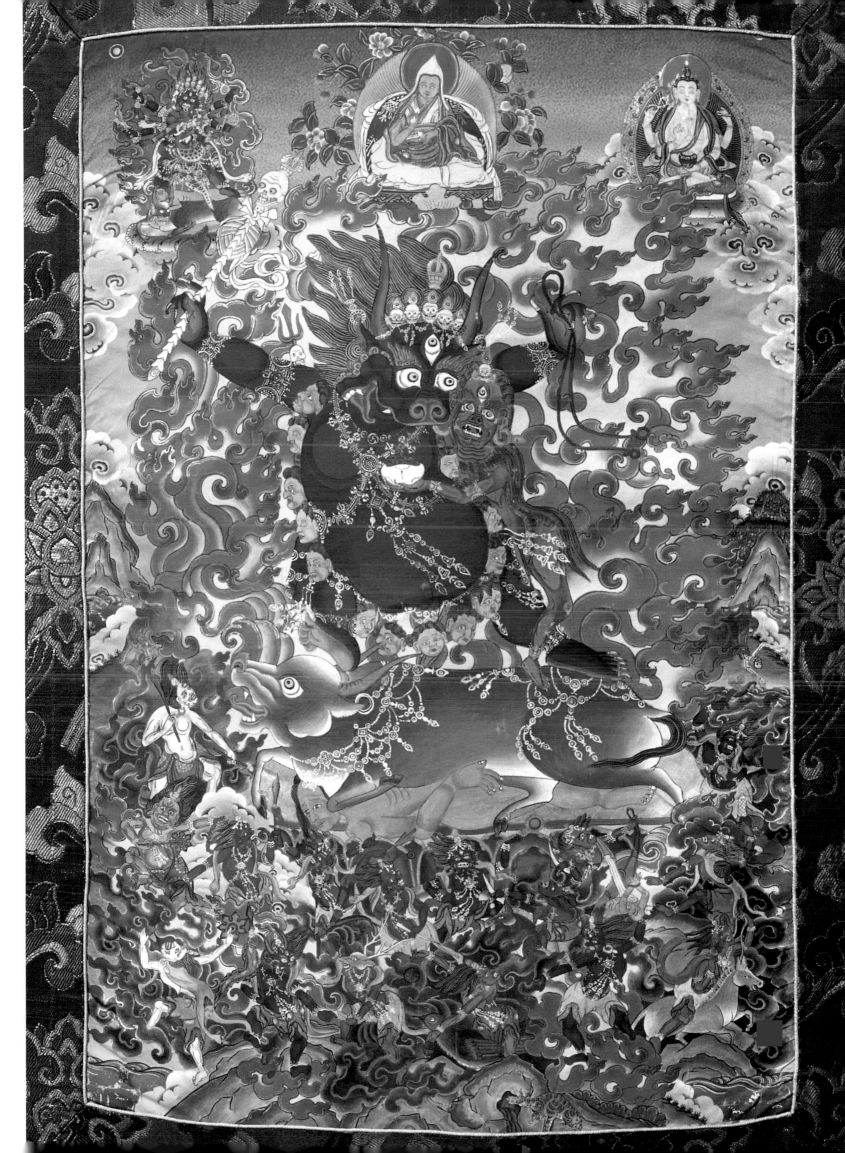

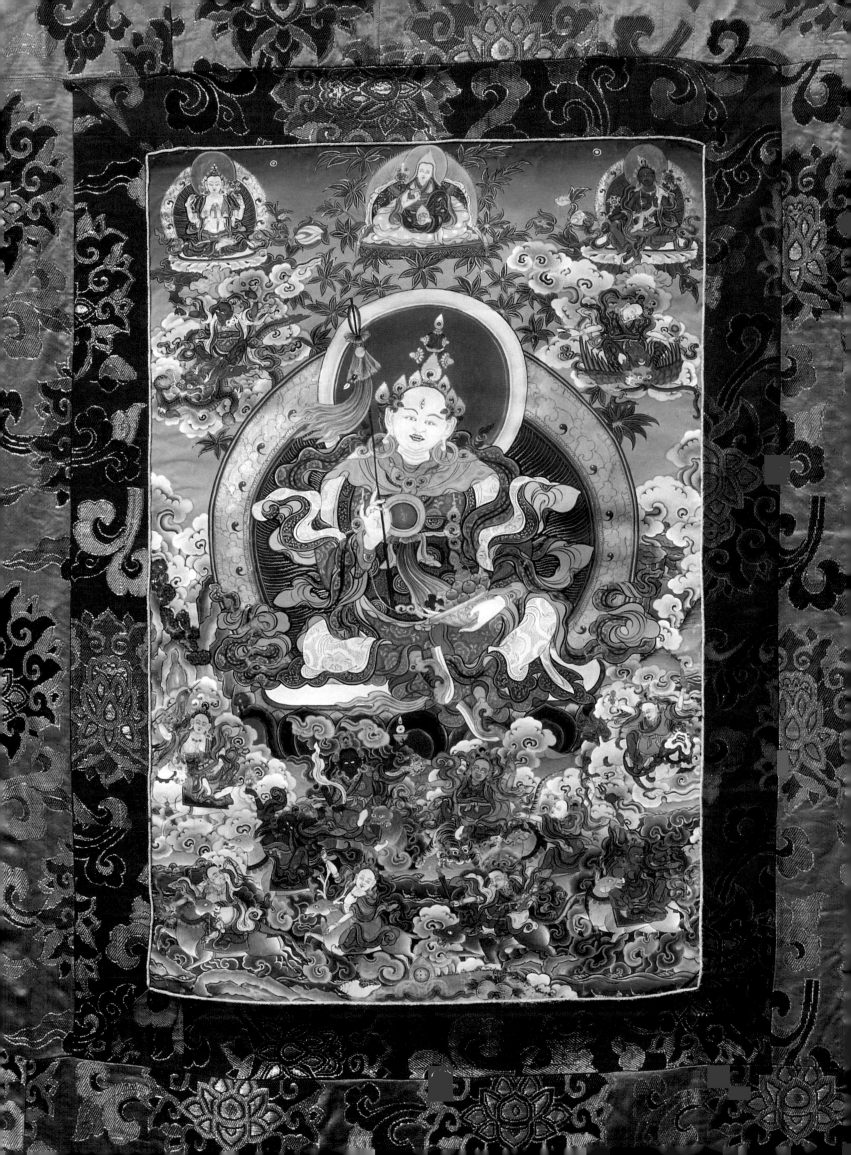

Classification of Thangkas
———— ✳ ————

Background and Sources

A thangka is a painted or embroidered banner which was hung in the monastry or the family altar and carried by lamas in ceremonial processions. The sacred paintings of Tibet may be classified broadly as mural paintings (Tibetan: *debs-ris*) done on the walls of monasteries as well as manuscript covers (Tibetan: *dBwha*), miniature paintings done on initiation cards (*tsakalis*) and paintings on cloth—the thangka. In a country ridden with esotericism and mysticism, thangkas are considered to be treasures of tremendous value. As a major form of Tibetan painting they were conceived and designed as objects of religious devotion or a basis for meditation or prized as sources of miraculous power.

In Tibetan the word *than* means flat and the suffix *ka* stands for painting. In every case the derived meaning would lead one towards the understanding of a kind of painting done on flat surface but which can be rolled up when not required for display. The most common shape of a thangka is the upright rectangular form. One does also find horizontal oblong banners influenced probably by the format of Chinese horizontal handscrolls. When the painting is complete in all its details it is mounted on silk. Some of the early fifteenth and sixteenth century thangkas have thin borders made of red and yellow silk strips and a plain blue silk mount. At a slightly later date some of the monastic guilds started using elaborately brocaded Chinese silks for mounting. Such fabrics were sent as gifts by Chinese emperors to the major monastic establishments of Tibet.

To protect the painted surface from dust and from the smoke of butter lamps thangkas are draped with gossamer thin silk covers (*zal-khebs*). Two wooden rollers are attached at the bottom and at the top, the former is often provided with decorative knobs at its two ends. The mounted thangka, flanked with two hanging coloured bands attached to the upper end and having the silk cover gathered up to the top, hangs majestically on an altar. It then receives the blessed touch of the lamas who reciting the Buddhist canon add their hand prints in gold or cinnabar and inscribe the three holy syllables *'OM AH HUM'* together with syllabic combinations of the seed *mantra* of various deities on the reverse side. Often, personal seals of holy teachers or living Buddhas are also imprinted. Such consecration ceremonies are performed not only on thangkas but also on bronze icons, and on illustrated and non-illustrated manuscripts to bestow spiritual efficacy on the painted images with prayers and special

Facing page: Tenma deity. Tenma is a local deity worshipped by the monks of the Namgyal order. Her origin is Tibetan, specifically of the post-Padmasambhava era. Contemporary. Collection: Namgyal Monastery.

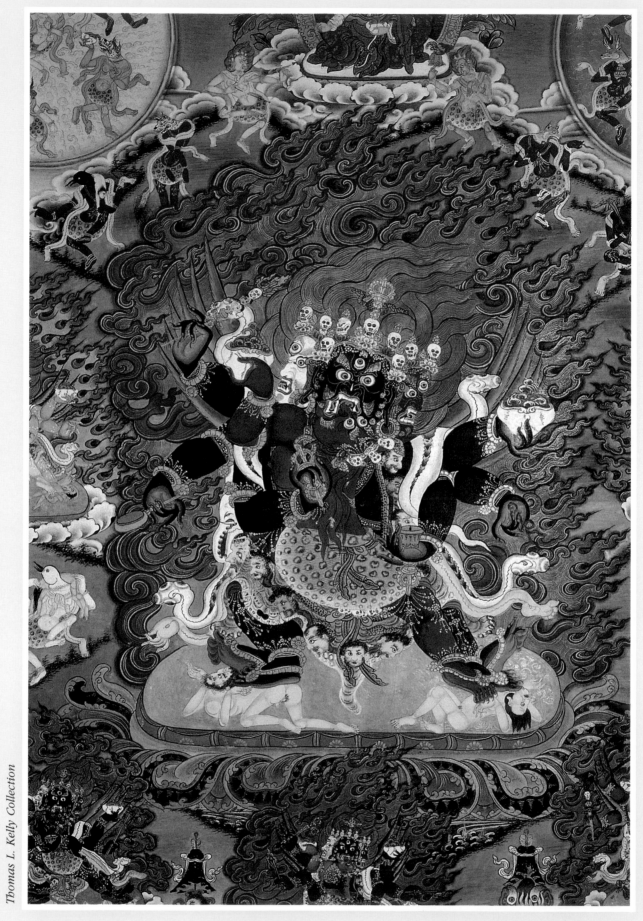

The winged Chechog Heruka with three faces, six arms, embracing his consort, 18th century.

invocations. These ceremonies are performed not only on the newly-finished creations but can be repeated subsequently as often as required. Finally, there are wooden dowels to make it easy to roll up the thangkas for storage.

Preferred supports for thangka paintings are cotton and linen; the use of silk for this purpose is indeed rare. Although experts have opined this to be a result of Indian influence, there is no early Indian example existing to complement the above theory, and all the painted scrolls belonging to the fifteenth and later centuries have cotton or linen as their support. Even early Nepali scrolls (known as *paubhas* locally) which are contemporary to so many early Tibetan counterparts, are all painted on a cotton or linen base. Chinese models definitely inspired the Tibetan artist but could never succeed in making them discontinue their traditional ways of painting, in favour of silk.

The tradition of painted scrolls or *chitrapatas* had an early origin in India and a gleaning from the literary sources would reveal that the support chosen by the ancient painters was a type of coarse fabric, *dussa*. The Sanskrit Buddhist text *Ashokavadana* (first century AD) narrates the temptations of Mara who assumed the form of Buddha and resembled an actual painted image of the Lord with all the auspicious signs 'in diverse colours on fine new cotton cloth'.

Painted scrolls were used in Buddhist India and even in Central Asia by the itinerant story tellers who with the help of narrative scrolls or *akhyanapatas* popularised the religious and secular literary themes amidst the masses. Even in Tibet there was a similar kind of artist minstrel called Mani lama who wandered about the streets and alleys reciting and singing narratives and showing parallel visuals on thangkas. Such performances, needless to add, had a spontaneous popular appeal.

Among the connoisseurs of thangka, those of the elite class preserved old thangkas as precious heirlooms. The ordinary people also commissioned thangkas for routine worship or to commemorate certain events. Displayed in large numbers in the prayer halls and living quarters of lamaseries, these painted banners evoke a sublime aesthetic experience.

Types of Thangka

On the basis of techniques involved and materials used thangkas can be grouped into several categories. Generally they are divided into two broad types: those which are painted called *bris-than* in Tibetan and those which are made of silk either by weaving or with embroidery called *gos-than*. In the *gos-than* there are five sub varieties namely, (a) the hand embroidered ones with coloured silk threads (*tshem-drub-ma*); (b) the ones done in applique technique (*dras-drub-ma*); (c) the ones made by pasting coloured silks of different shades with glue on the canvas base (*lHan-thabs-ma*); (d) the silk hand-woven type (*thag-drub-ma*) and (e) the printed ones made with the help of wooden, copper and iron blocks (*d'Par-ma*). Large silk thangkas of majestic proportions are known as *gos-sku*. They are meant for display on special occasions on the outer walls of temples. One such

gigantic *gos-sku* thangka is in the Potala palace, measuring approximately 55 m, 8 cm by 46 m, 81 cm. This was made in the late seventeenth century after the demise of the Fifth Dalai Lama and represents Dhyani Buddha Amitabha. Some of the hand embroidered thangkas have pearls and precious stones attached to the fabric with gold thread and look resplendent.

Painted thangkas are of various types. Some of the major forms are: (a) those having different colours in the background; (b) those which are painted on a cold-gold background; (c) those which have a red vermilion background; (d) those painted on a black background and (e) those whose outlines are printed on the cotton support and then touched up with colours.

Mandalas, which are circular in form with several divisions and subdivisions are painted generally on a square cotton support in a technique similar to thangkas with different colours in the background. There are mandalas painted in a rectangular format but in that case the deities surrounding the central psycho-cosmic diagram are depicted in an upright position which enhances the vertical effect when placed on the brocade mount.

Subjects Represented

Inspite of being a highly developed means of religious expression, one cannot overlook the fact that thangkas are 'not always inspired by a joyful or pious urge to produce an object for worship'. Ordinary people commission a thangka quite often under circumstances sad or unavoidable which they want to overcome with the propitiation of certain deities. A painter will usually give three reasons behind commissioning a painted banner which has ample justification in a traditional social set-up. These are: sickness or trouble, death in the family and the need for an image for the performance of certain rituals. The commissioning and donation of thangkas to monasteries has always been held as a meritorious act for both, the patron and the artist. Thus apart from using the paintings for routine worship they are also used for special occasions and are referred to as *naimitikka*. Those meant for offering to the lamaseries are called *naivedika*.

Generally Tibetan priests often advise those confronted with physical or mental obstacles to commission a thangka and perform rites to abate these obstacles or nullify them totally. For example a thangka with the depiction of Tara always bestows protection and removes obstacles of all sorts, those representing Amitayus assure longevity, those with the representation of Bhaisajyaguru or the Medicine Buddha has the power of healing and the ones painted with any of the manifestations of Vaishravana enhances well-being and wealth.

Thangkas painted for funeral observances are called signs of good birth. These are commissioned after the name of the deceased and have to

Facing page: Heruka with consort. Heruka is the terrific form of Samantabhadra, the primordial Buddha of the Nyingma Order. Contemporary. Collection: Namgyal Monastery.

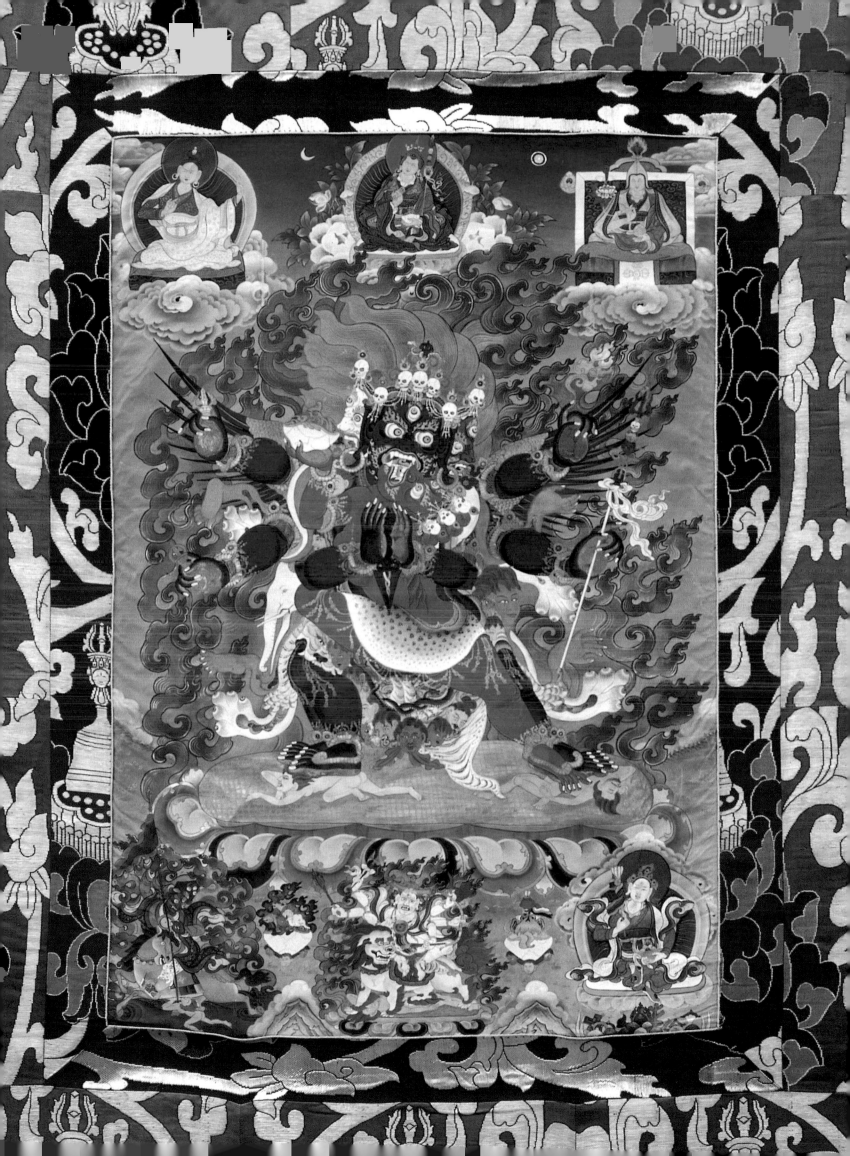

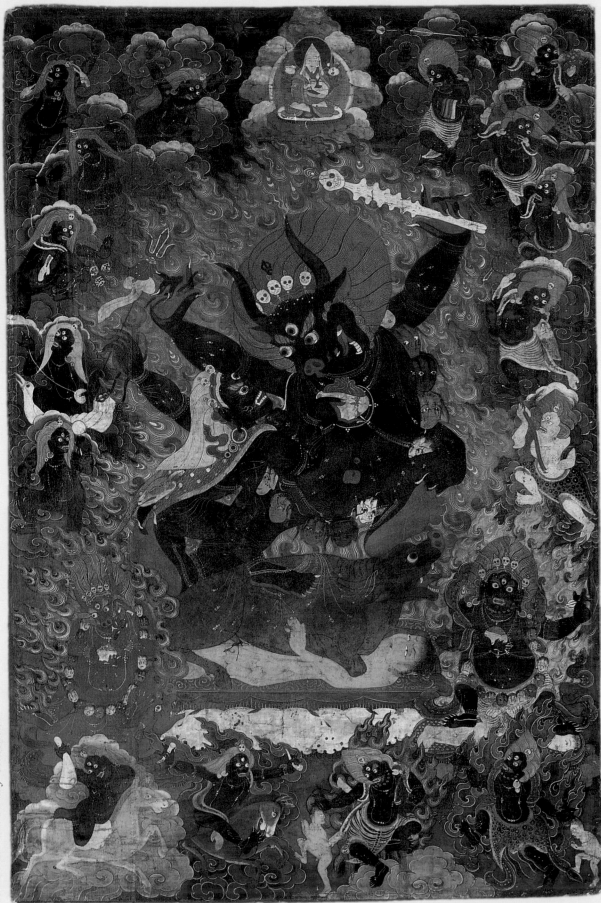

48

be completed within the seven-week period following a person's death. It is believed that during this phase the dead have still not entered into the process of rebirth. Lamas determine the appropriate manifestation of certain astrological treatises which are then painted and subsequently undergo the rituals of consecration.

The dominant themes of thangkas are of religious significance. The portrayals of Buddha Sakyamuni and his twelve deeds form a major group. Dhyani Buddhas, their mystical consorts and corresponding Bodhisattvas may be placed in another group and together with the exhaustive representations of the Vajrayana pantheon form the most important category. Next come the subjects of hagiographical interest which includes the portraits of scholar-saints and depictions of events from their mythological biographies. Mandalas or spheres of divine residence of various deities belong to a separate category. There are also themes like the depiction of the founding of monasteries, paintings of the offerings made to deities, paintings of the wheel of *samsara* or existence and paintings to ward off evil from all directions. Reinterpretation of historical themes through painting is an outstanding feature of thangkas. These include historical themes and scenes from the stories of epics and their heroes. Depictions of other subjects include the eight good luck symbols of Tibet (*tashi thargye*), seven precious articles of royalty (*rgyal-srid snabdun*), the seven precious jewels (*nor-bu-chabdun*) and many more such symbols from Tibetan mythology.

There are also paintings completely non-religious in character like the conceptual depictions of the beginning, the present state and the end of the world; legendary tales and representations of flowers and medicinal herbs and other similar objects. Thangkas meant for esoteric ritual worship or meditational purposes are meant only for those initiated into the tantric tradition.

The donors of a painting, particularly in the examples of Nepalese works, are always portrayed slightly distanced from the central image and the spheres of supplementary figures. The male donor figures are placed on the heraldic right and their consorts on the left, one behind the other in a row on the lower-most register or compositional zone.

Facing page: Yama Dharmaraja, Central Tibet, mid 17th century. The buffalo-headed Lord of Death, an important deity of the Gelukpa order, gazes fixedly into the face of his blonde-haired consort Chamundi.

49

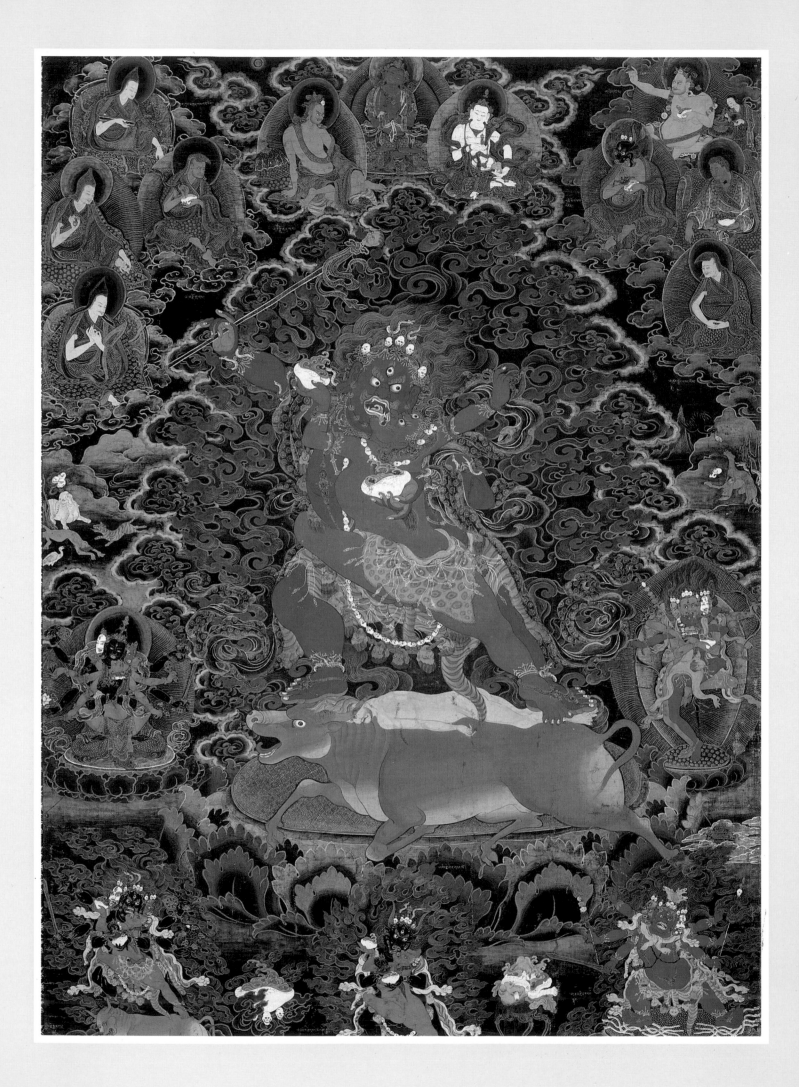

Technique of Thangka Painting

✳

Thangkas are painted in a technique close to tempera (a process of painting using pigments mixed with size, casein or egg instead of oil) on sized cotton canvas with water-soluble pigments, both mineral and organic, tempered with a herb and glue solution. The entire process demands great mastery over the drawing, perfect understanding of iconometric principles and patience. Like many other traditional artists, Tibetan painters never suffered from any anticraft attitude and this is the reason behind their effortless control of the intricate technical knowledge, detailed knowledge of past procedures and its dynamic utilisation in a fresh context. The technique of thangka painting can be better understood in its six-fold step by step progression. These are: (a) preparation of the painting surface; (b) transfer of the drawing on to the support; (c) application of paint; (d) shading and colour gradations; (e) outlining and (f) finishing details. An exaggerated concern with technique in rare cases might make the approach sterile but can never hamper expression. Moreover, the painters have a certain responsibility to the patrons and can never afford to ignore matters of craft. A thangka that cracks, warps, fades or crumbles is not suitable for worship and may hamper the devotee's invocation.

Indian *chitrapatas* served as an archetype to the painters of Nepal, Central Asia and even Tibet. The technique of painting on palm leaves and wooden covers in the Pala era (eighth-eleventh centuries AD) which was adopted by the manuscript illuminators of Nepal was a kind of tempera done with organic and mineral colour pigments tempered with glue. The well-known Buddhist murals in the caves of Ajanta were also done in the tempera process. In fact, the technique of painting the *chitrapatas* and banners which must have evolved during this period was another variant of tempera on well-treated cotton support. Any assumption of this sort can be supported with a literary reference from an important tantric text, *Manjushrimulakalpa* of the third century AD. This indeed is the earliest description of the process of painting on cloth and has great affinity to the basics of thangka painting:

> The cloth is to be woven by a pure virgin, and its preparation is accompanied by an elaborate ritual . . . The whole ritual is conducted by an officiant (*sadhaka* or *acharya*) who may either do the work himself, or employ a painter who works under his direction. Pure colours are to be used. The painter, beginning his work on an auspicious day, should work only from sunrise to midday; seated on a cushion or *kusha* grass, facing the east, his intelligence awake, his mind

Facing page: Red Yamari with consort. Central Tibet, late 17th or early 18th century. The beauty of this black thangka rests on the precisely brushed lines of blue and pink, and on the translucent mashes of orange, pink and light blue. Collection: Museum of Fine Arts, Boston.

directed towards the Buddhas and Bodhisattvas; he takes in hand a delicate brush (*vartika*) and with his mind at ease, begins to paint. After the prescribed divinities, etc. have been figured, he should depict the officiant himself, in a corner of the canvas, according to his actual appearance and costume, kneeling with bowed head, holding an incense burner . . .

<div align="right">(tr. A.K. Coomaraswamy)</div>

In the monastic guilds of Nalanda along with the widespread tradition of manuscript painting there continued a parallel trend of painting religious

The painter tightening the cloth on to the stretcher.

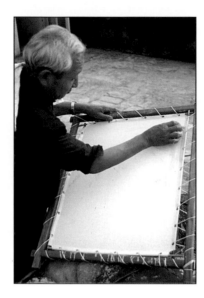

Application of gesso ground.

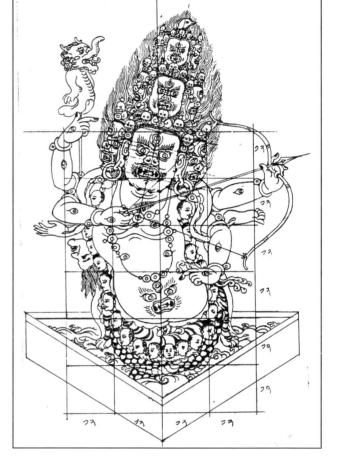

The drawing of a standing deity with grid marks.

themes on fabric. A Chinese account of Hua Chi of Teng Ch'un published in AD 1167 gives the following vivid account:

> In India, at the temple of Nalanda, the priests paint many Buddhas, Bodhisattvas, and Lohans, using the cotton of the west. The features of their Buddhas are very different from Chinese features; the eyes are larger, and the mouths and ears are curiously shaped; the figures wear girdles, and have the right shoulder bare, and are either in sitting or standing attitudes. The artist begins by drawing the five organs at the back of the picture; on the other side he paints the figure in colours, using gold or vermilion as a ground. They object to ox glue (probably a medium prepared from buffalo skin) as too noticeable, and take the gum from peach-trees mixed with the juice of the willow, which is very strong, but quite unknown in China.

<div align="right">(tr. H.A. Giles)</div>

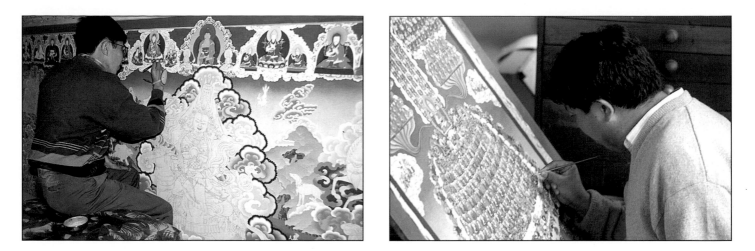

Application of paint at a later stage. *Giving the final touches.*

Fortunately in Tibet and Nepal this type of painting tradition found a congenial home while it dwindled steadily to a vanishing point in the land of its birth and maturation due to the ruthless iconoclasm of the Islamic invaders.

Preparation of the Painting Surface

Tibetan painters attach great importance to the preparation of the painting surface and the gesso ground since the cloth support is rolled up for storage and then unrolled for display. Any sort of defect due to neglect may cause cracks or make the paint peel off. A piece of cotton cloth of even but slightly open weave is stitched on to a narrow wooden frame along all its four sides. Very often additional strips of fabric are stitched to the principal one to achieve the desired length for the painting. Moreover, such joints are hard to notice in the finished thangkas. The lightly framed cotton support is then tightly stretched over a larger wooden frame with a stout thread by a system of crisscross lacing. After setting up the cloth in the frame it is treated from both the front and back with a thin layer of

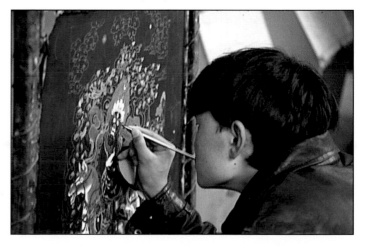

Applying the gold detail. *Applying gold to a* nagthang *(black) thangka.*

53

gelatin or size prepared from organic matter. Sizing prevents the paint from getting absorbed into the fabric, from cracking and from turning dull. Next a mixture of chalk or white porcelain clay, size solution and water is applied on both sides of the fabric with a special knife. Polishing the gesso ground by placing the stretched cloth on a plain level surface is the concluding part. In order to achieve a smooth surface painters polish both the sides with a polishing stone or with a conch shell by moistening parts of gesso and working along the axis of the cloth. Thus they achieve a smooth surface in which the texture of the cloth is hardly visible and it turns as pliant as soft deer skin.

Technique of Transfer of Drawing

The technique of painting thangkas demands precision and a slow building-up process with pigments having little covering power, as in the egg or casein tempera paintings of medieval Europe. It has to have a design distinct in its demarcation of areas and with little convolution. Tibetan painters have standardised compositional structures for various deities and didactic paintings. Such compositions consist of a central figure and an established group of lesser figures as part of the former's retinue. Similarly, the complete transmission lineage of a particular school of Vajrayana teaching is depicted in two different types of group compositions. They are 'Refuge Tree' and 'Assembly Fields'. Generally the hierarchical stratification maintains the following sequence:

1. Gurus, 2. Protective Deities, 3. Buddhas, 4. Bodhisattvas, 5. Daka and Dakini, 6. Dharmapala, 7. Yaksha, 8. Gods of wealth, 9. Lesser deities.

Within these traditionally approved layouts there is very little chance for the painter to express his own sensibility except in parts of purely decorative appeal or of landscapic expanse.

Before sketching the different parts of the composition eight major lines of orientation are drawn. These include a central perpendicular, two diagonals, a horizontal and four outer borders. Now with charcoal or graphite the rough drawing of the deity in full accordance with the canonical proportions is delineated. The proportions of each deity, according to the Buddhist texts of iconometry, have been classified into two main units of measure: small units and large units. Every novice artist uses an iconometric grid specifying exact numbers of lines for the initial sketches. The details of the parts of figures are drawn with the help of anthologies of drawings and preparatory sketches in possession of families of traditional artisans. Such pattern books of visual models are important documents for the analysis of style. The two dated sketch books by Nevar painters of great art historical value are the one by Jivarama dating from 1435 and the other by Srimantadeva bearing the date 1653. At times repetitive images or a long sequence of patterns with repeating motifs is transferred with the help of pounced drawings. Pounces are made by drawing the motifs on paper which are then punctured along their silhouette with a needle. Such perforated drawings are kept on the painting surface and then they are gently dusted with a mixture of

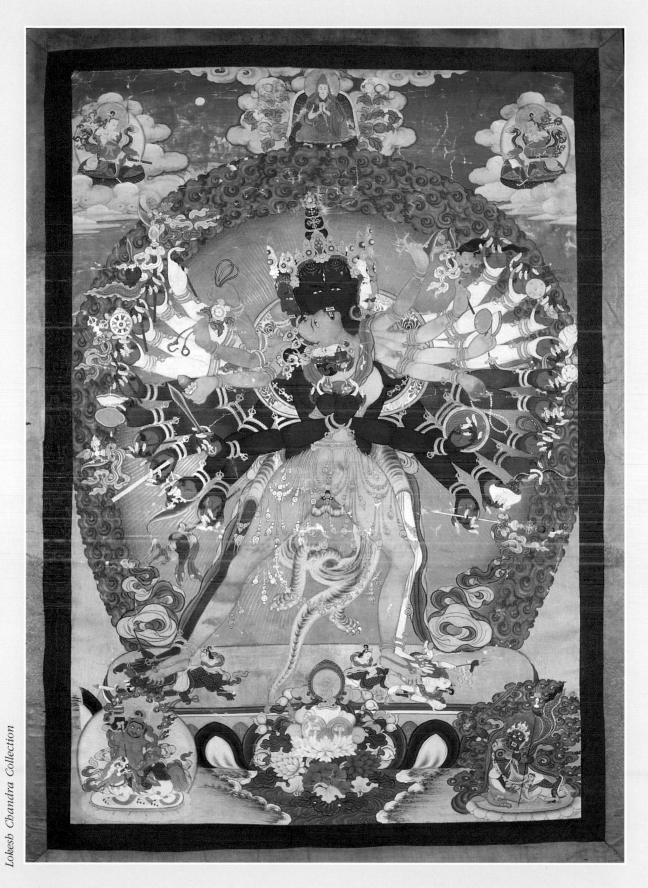

Kalachakra with consort. Nineteenth century. Intricately detailed jewellery and implements complement the shapely contours of the limb.

charcoal and ochre powder. Finally, the correct drawing is gone over with a brush dipped in black ink. Around 1800, under Chinese influence, carved xylograph blocks were also used for compositional drawings.

Application of Paint

It is important to remember that colour is more than a visual proposition in tantric Buddhist art. Through colour symbolisms the devotee gives expression to his psychic experience. The basic five colours namely, white, yellow, red, black and green have different symbolic meanings. According to *Chanda Maharoshana Tantra*, a text of Vajrayana rituals, black symbolises killing and anger, white denotes rest and repose, yellow stands for restraint and nourishment, red is indicative of subjugation while green is the known hue of exorcising practices. *Guhyasamaja Tantra, Sadhanamala* and other later texts associate the five Dhyani Buddhas to five colours which correspond to their mystical super-nature, to their clans and to the cosmic energy they are endowed with. Thus the colour white is the prescribed hue of Vairochana symbolising delusion, yellow of Ratnasambhava denoting pride, blue for Akshobhya standing for hatred, red of Amitabha denoting passion and the green of Amoghasiddhi symbolising envy. The *Cakrasamvara Tantra* categorically states the colours appropriate for the walls and for the inner realm of a mandala. Numerous passages may be quoted from different tantric texts to explain the bewildering shades of symbolism related to the use of colours and their justification.

The palette of the thangka painters which comprises mainly of pigments of mineral extraction has been classified according to one tradition into 'seven father colours' and 'one mother colour'. The seven 'father colours' are: deep blue, green, vermilion, minimum orange, lac-dye maroon, orpiment yellow and indigo. The 'mother colour' is white which interacts perfectly with all these hues. The lighter shades resulting from the mixture of 'father' and 'mother' colours were referred to as their 'sons'; an eighteenth century non-canonical Tibetan text *Sum-pa Mkhan Po* gives a list of fourteen such 'sons'. Once any large project is undertaken the master painter visualises the final colour scheme and indicates them on the sketch with an abbreviated notation system using either numerals or the consonantal elements of the names of the colours.

The blue of the thangka palette is azurite blue, a basic carbonate of copper and the green is derived from the malachite variant of the carbonate of copper. For the luminous reds Tibetans used both the native mercury sulphide and the mineral cinnabar. Minimum orange is also known as red lead and is actually the synthetic tetraoxide of lead. The fine-grained earthy variety of the mineral limonite, a hydrated ferric oxide is yellow ochre, seldom used by Tibetan thangka painters. It is, however, used as a base for gold. The major yellows are realgar, a natural arsenic disulphide and orpiment or king's yellow, a natural trisulphide of arsenic. The most

Facing page: Paramsukha Chakrasamvara (literally, 'joined to the wheel of wisdom and bliss') with red consort Vajravarahi. Contemporary. Collection: Namgyal Monastery.

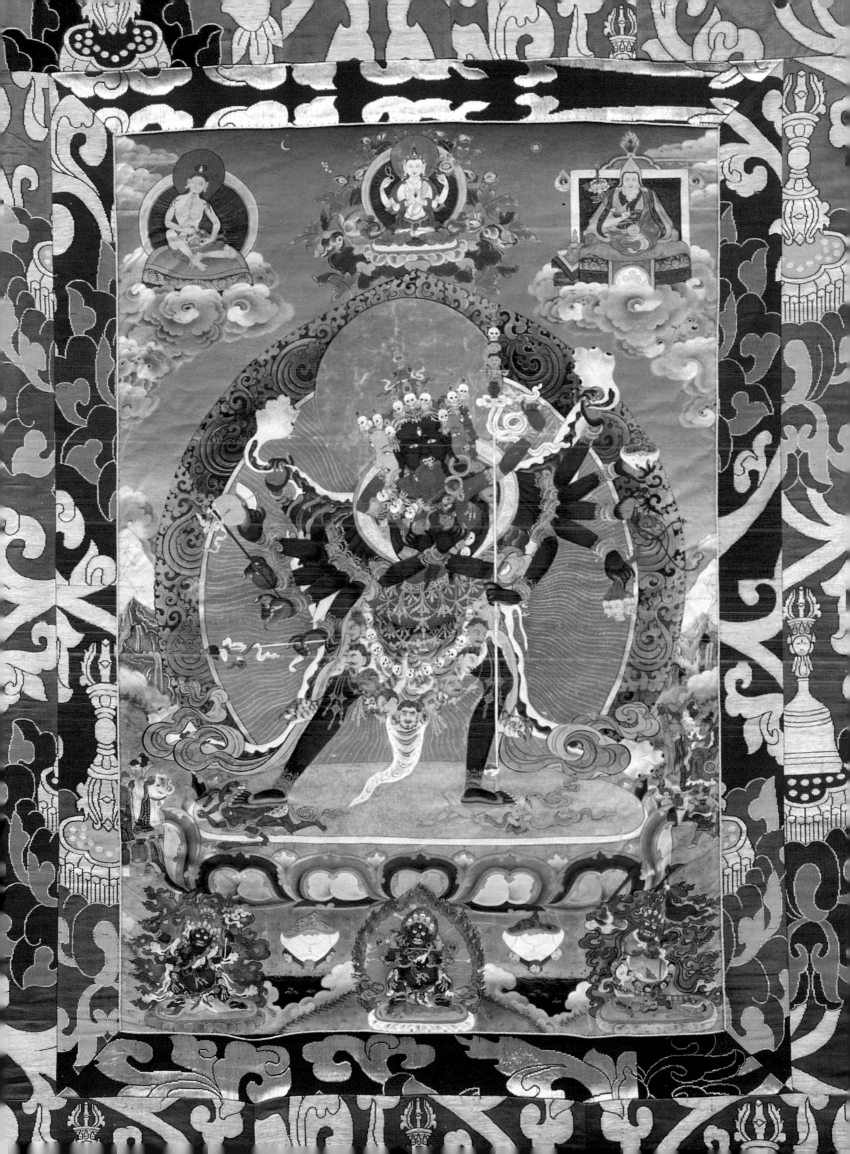

commonly used white pigment is a high-grade white chalk. Soot and black ash are the two most common organic sources for black paint. Tibetans use various forms of gold as pigments; the three well known varieties of gold paint are gold powder, gold lead and mercury-gold amalgam. The powdered gold tempered with glue is known as 'cold gold' and this has been found most suitable for painting. For shading and outlining thangka painters use organic dyes and lakes. Indigo, a dark blue dyestuff was obtained from the plant *Genus indigofera.* Lac dye, a crimson dyestuff is prepared with resinous secretions of tiny lac insects (*Laccifer lacca*) obtained from the warmer foothills of the eastern Himalaya in India. In addition to indigo and lac dye, Tibetan painters also use yellow organic dye made from the petals of wild rose, barberry bark and rhubarb roots. Similarly a warm reddish-brown dye, ideal for shading is made from red sandalwood.

Pigments are ground in a mortar and then cleaned by changing the water from the non-porous containers in which they are dissolved. The right amount of glue or size is added to temper the pigment and turn it into a consistency ideal for painting. While applying the colours on the support the painter proceeds from the distant part to those parts stationed near him. Very often the empty green field of the foreground is shown fading gradually into the horizon and such effects are obtained with 'wet shading', a technique of gradual blending of two adjoining areas of wet paint.

Shading and Colour Gradations

After laying the initial coats of flat colour the painter proceeds to apply the thin coats of dyes diluted in water. Shading in Tibetan thangkas is always done to add effects of volume and dimension to the form be it a human figure, an anthropomorphic image of some deity or clouds, water, flames, rocks and crags, flowers, nimbuses, curtains, seats, etc. Cast shadows and highlights are unknown aspects of the pictorial imagery of the thangka. Master painters of Tibet discovered at a very early date the process of intensifying a patch of flat colour with a corresponding dye. Such gradual transitions of tone had a basis of chromatic values: blue and green colours were treated with indigo to excellent effect. In the same manner areas of yellow, orange, flesh tint and red, when enhanced with lac dye, produced splendid effects of progression.

The technique of 'wet shading', as has been mentioned earlier, is a part of colour application at the initial stage. 'Dry shading', which involves at least four different kinds of strippling or granular shading, is done when the initial coats of paint are dry.

Outlining

In an essentially linear pictorial expression like the thangka, the art of outlining undoubtedly plays a significant role. To set off objects from the

Facing page: White Mahakala, the more unusual representation of the most popular protector deity of Tibetan Buddhism. Contemporary. Collection: Namgyal Monastery.

58

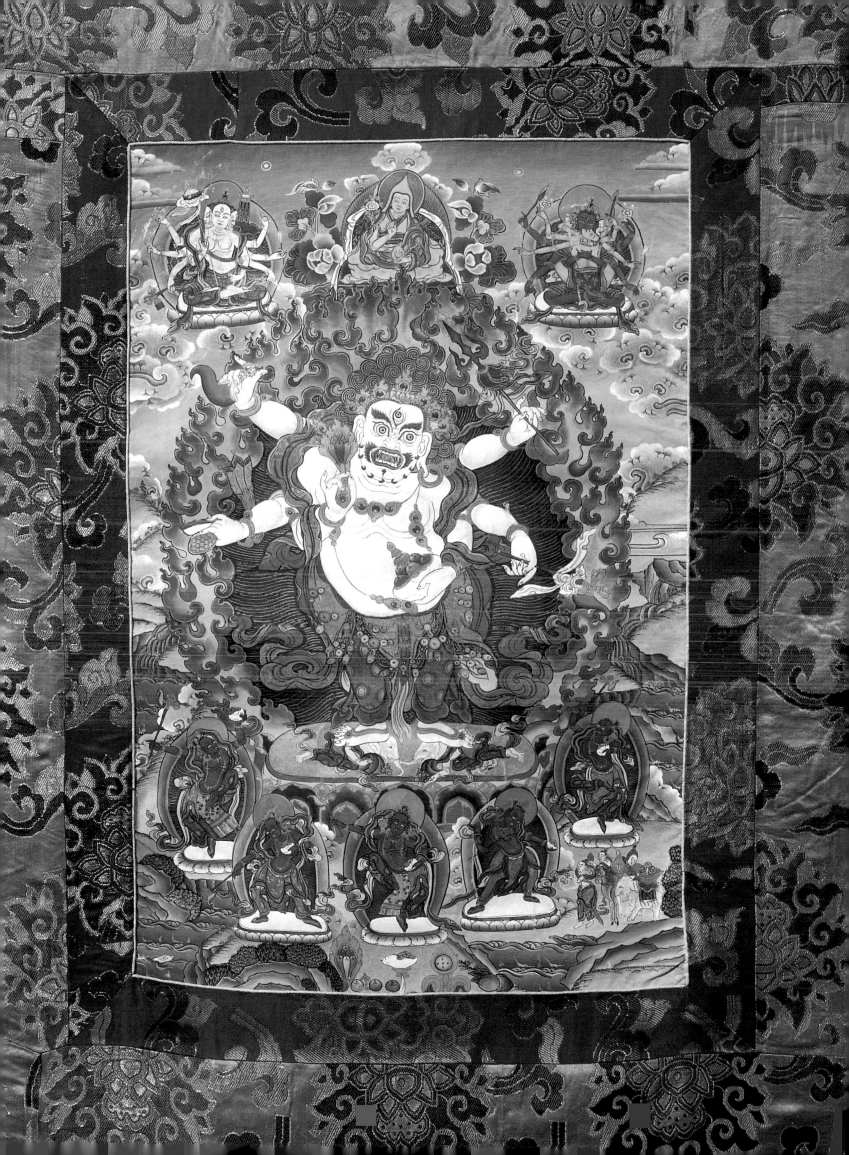

background or to demarcate subdivisions of a certain form, to emphasise a swirling mass of flames or to lift the brocaded designs of the fabric, painters use a wide range of outlining methods. For outlining, the painters again select the indigo and the lac dyes for perfect results. Linear detailing in white is done to model the rippled water surface as also to delineate the details of the bone ornaments and the pearl jewellery of tantric deities. Outlining in gold enabled the golden brocade designs, gold jewellery and ornaments to stand out in greater relief. An aphoristic remark of a master painter of thangkas has a subtle message of perfection an artist is expected to strive for relentlessly:

> The waist (of an outlining stroke), since it
> is the 'wealth' (of the stroke), must be wide.
> The point (of the outlining stroke), since it
> is a 'virtue', must be sharp.
>
> (tr. David & Janice Jackson)

Finishing Details

At this final stage the facial features are finished and the eyes of the deities are painted. For this 'eye opening' an elaborate consecration ritual and an auspicious day, invariably on a full-moon, is fixed and only after the vivification ritual does the painter complete the eyes in sure swift strokes. The whites of the eyes are softened with orange and red at the corner ends, eyelid edges are darkened and then the iris is added according to the required stance of the deity. The two most commonly fashioned varieties of eyes are 'bow eyes' and 'grain eyes' besides a few fearsome looking ones for the wrathful deities.

In order to turn the areas of gold shiny they are burnished gently with an onyx tipped tool after placing a wooden support against the back of the canvas.

Next, the cord fastenings are cut with a knife and the painting is removed from the stretcher. The thangka is then mounted with Chinese silks. Two thin bands of yellow and orange-red silk representing a mystic rainbow emanating from the divinity surround the edges of the thangka. In some thangkas a piece of fabric, other than the one used for the mount, is attached at the lower section. This is called 'the door of the thangka' and has a certain esoteric role in meditation sessions. Quite frequently this applied patch of silk is wrought with figures of dragons or nagas or lotuses symbolising the sphere of cosmic waters.

Facing page: Manjushri, the Bodhisattva of Transcendent Wisdom, Nepali paubha. Fifteenth century. Collection: Thomas L. Kelly/Arnold Lieberman.

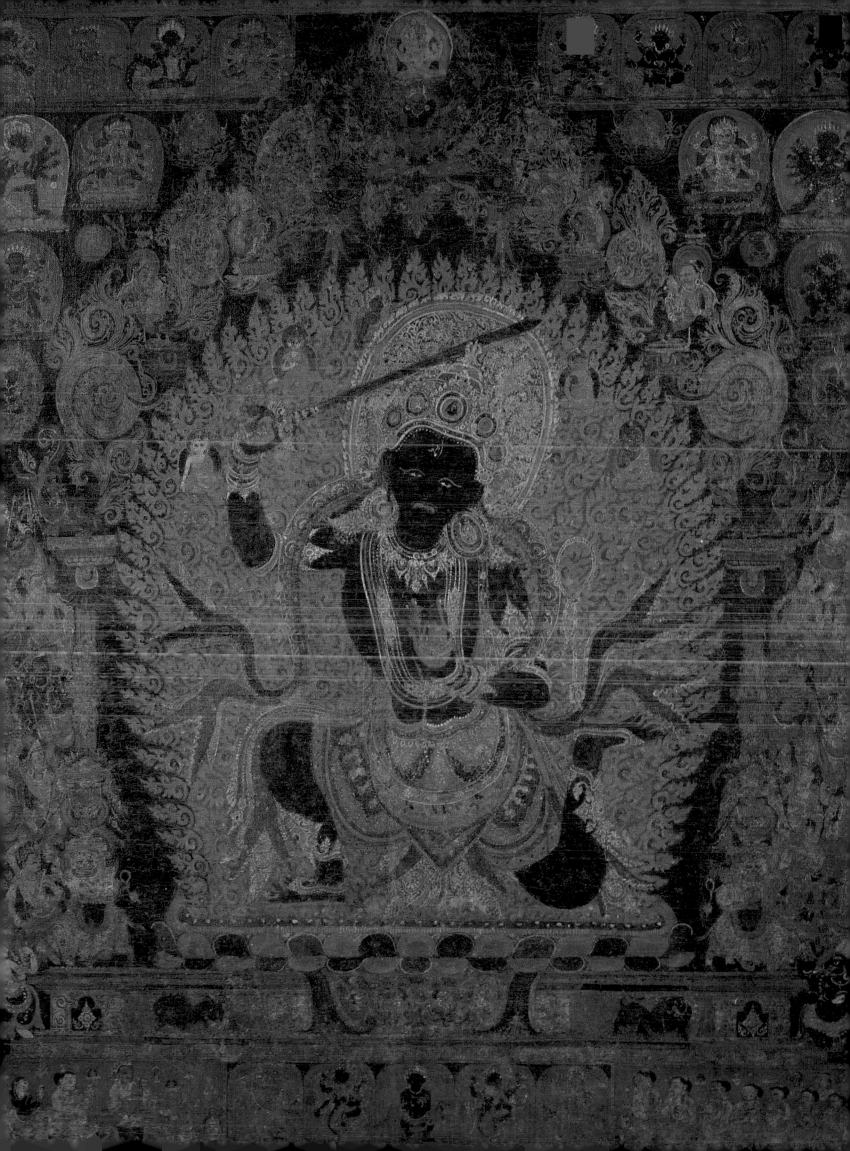

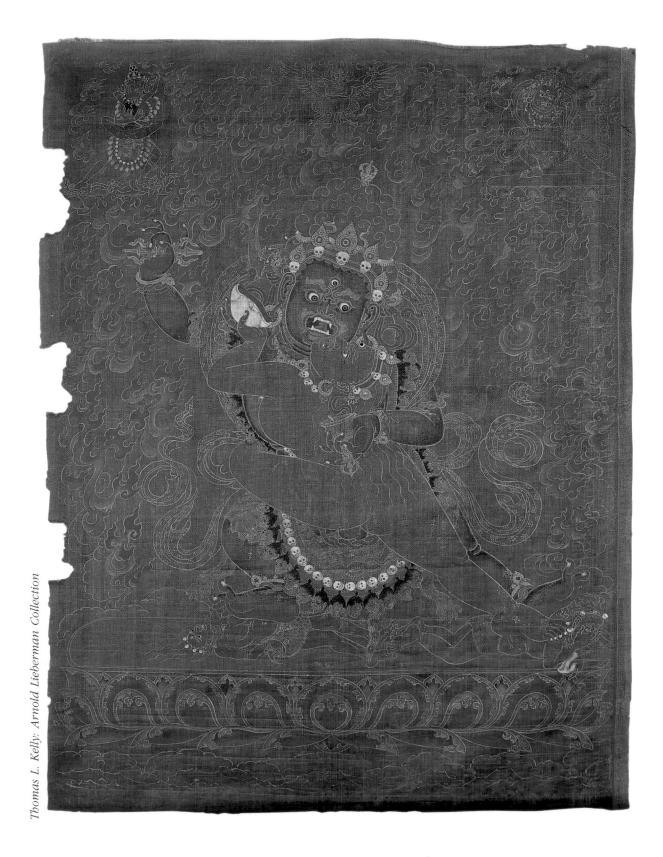

Mahakala with consort, Central Tibet. Seventeenth century.

The Painter's World
✳

Works of art were rightly thought to be precious windows on 'the enlightened dimension' and icons were virtually receptacles of the divine presence of deities. Ritual worship, consecration as well as the sanctifying touch of the lamas considerably enhanced the spiritual potency of the images. An anecdote from the mystical biography of Tsong-kha-pa (1357—1419), the founder of the Geluk and the renewer of the early Kadam Order, is worth recounting in this context. Once in 1415 Tsong-kha-pa along with his disciples was fashioning a magnificent three-dimensional mandala *(blos-slang dkyil 'khor)* in gold and silver. When the images which are referred to in *tantra* as 'wisdom duplicates', neared completion in perfect accordance with the iconometric principles they suddenly started shining by themselves without any manual polishing. The deities descended from their celestial quarters and merged into the shapes crafted with great devotion.

The maker of images *(lha-bzo)* or the painter of a thangka need not necessarily be a monk. He can be either a cleric or a non-cleric but in every case he has to be 'serene as a selfless vessel' for all the divine inspiration that would flow into his being during the act of creation.

It is necessary for a painter of meditational deities to be an initiate of the *tantric* sect to which that deity belongs. Once he is received into one of the four *tantric* classes (action, performance, yoga and unexcelled yoga) he does not require any further initiation. A rite known as *rjes-gnan* is performed by a lama before any such painting is started. At times the artist has also to spend a period of time in meditational retreat under the guidance of a lama.

A harmonious relationship between an artist and a patron always proved ideal for the successful completion of an artwork. Any feeling of discord between the painter and the lama or the priest physician is never conducive to the smooth progress of the painting. The worn garments of lamas are rarely used for painting. Often the cloth to be used as a support for the thangka is kept for a short period in close proximity to a holy person before it is stretched and given a coat of gesso. During the period an artist is engaged in the creation of deities belonging to *kriya tantra* he observes certain restrictions prescribed in the text like abstinence from meat, alcohol, onion and garlic. There also exists the convention of adding things of sacred origin to the materials used in painting. Water of the pilgrimage centres, relics of a holy lama, powdered gold and silver, turquoise, coral and pearl, sweet smelling herbs and powdered saffron flowers, it is believed, enhance the magical efficiency of the artifact.

The thangka painters, a majority of whom were pious laymen, came from families of hereditary painters and image-makers. There were also quite a few of them who were not hereditary painters but turned to this profession as a result of their own interest and talent. They had to

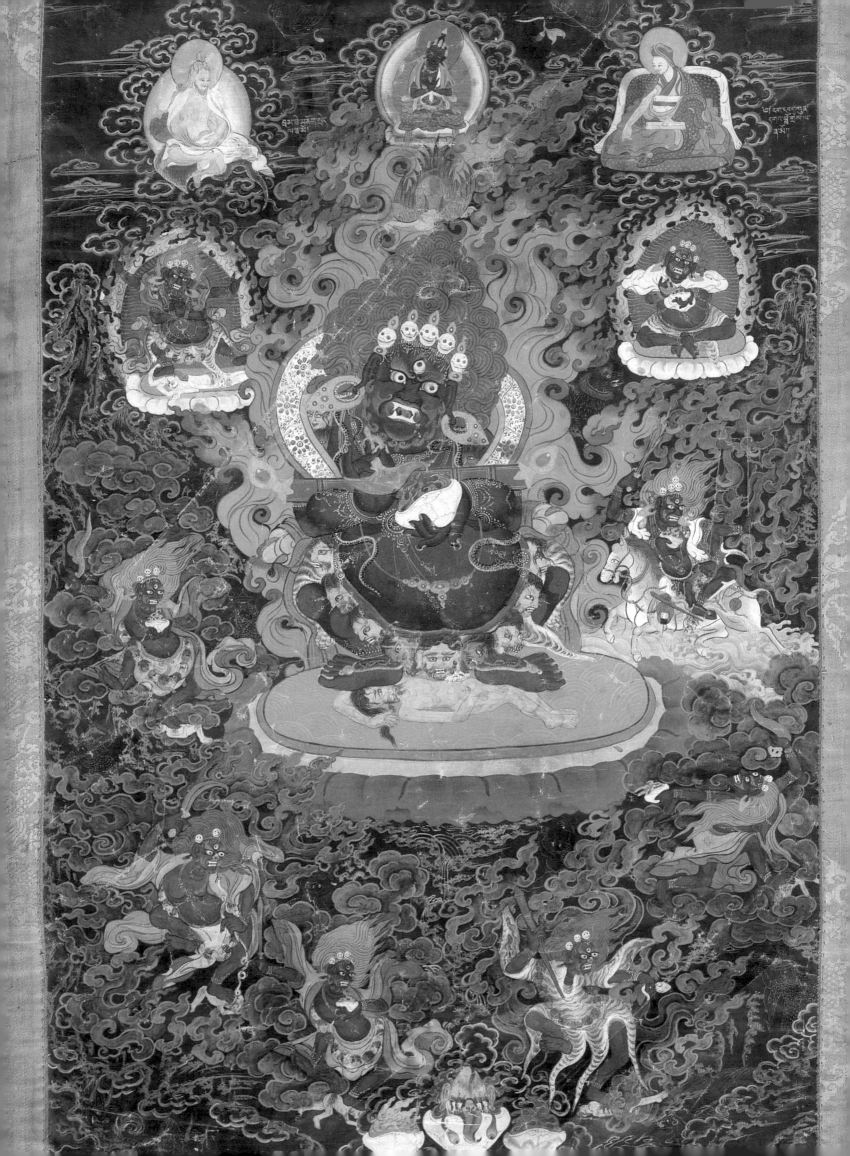

undergo years of arduous apprenticeship under master painters until they attained the required level of perfection to paint the eyes of the deities. The artists worked either in their own homes or in the house of the patron or, a monastery. Inscriptions on thangkas reveal that they were commissioned for a variety of purposes both individually and collectively. In exceptional cases it has also been mentioned how the money paid for a certain thangka was collected and how the actual amount of money was paid to the painter. *Vajravali tantra* (1124) by Abhayakaragupta, a text which discusses numerous mandalas and the associated mode of worship in accordance with the Vajrayana system, categorically mentions that the artist engaged for making the mandalas had to be paid the honorarium for his commission.

Evidences culled from biographies of lamas as well as artists prove the active involvement of lamas in planning, visualising , commissioning and even executing sacred objects of art. Quite a few of them were painters and image makers themselves and some of them received training from master artists before entering the monastic system.

Buton Rinpoche (1290—1364), an eminent polymath, was responsible for renovating the Shahe monastery and the Kumbum of Gyantse. The great Karma Pakshi (1206-1283) was probably a sculptor himself who, according to legend, made a fifty-five feet tall cast for the brass statue of Sakyamuni and consecrated it with sacred relics of the Master. Karmapa Rolpe Dorje (1343—1383) was once approached by his disciple, princess Prenyodhari of Minyak, who sought his help in the execution of an enormous thangka of Sakyamuni. Karmapa drew the initial design on the ground by riding his horse which was transferred on to a huge piece of silk and some five hundred artisans worked for thirteen months to give it final shape.

It is true that the difficult iconographic details laid down in *shilpa* texts and the rigid rules of iconometry were not easy for the lay artists to memorise and on such occasions they were helped by the lamas. Similarly, the visions of the deities lamas had during meditation were given shape very often conjointly by the artists and monks.

Gong-dkar-ba Kundga, a fifteenth century religious master, once had a vision late in the night of Mahakala in course of his meditation. The same night he prepared a sketch of the deity with all the details he saw in the apocalypse. The next morning the famous artist of the time, Mkhyen-brtse chen-mo was given the charge of completing the painting. Karmapa Mikyo Dorje, Karmapa Chosdbyings-rdo-rje and Situ Panchen ventured into the field of painting and their creations are held in high esteem. Karmapa Chosdbyings-rdo-rje as a result of having differences with the fifth Dalai Lama, Gyahua Lobzang Gyatso (1617-1682), devoted much of his later life to the evocation of deities with paint and brush.

The names documented in the inscriptions or chronicles reveal that besides those of local origin, there were painters and image makers from

Facing page: Mahakala, unquestionably the most important Dharmapala (protector of Dharma), is depicted here with companions. Central Tibet, Sakyapa Monastery. Nineteenth century. Collection: Los Angeles County Museum of Art.

Nepal, Kashmir, Central Asia (specially Khoran) and China active in different regions of Tibet under the patronage of different monastic orders. It was indeed a rare exception rather than the rule for the artist to sign any of his creations. In general they preferred to remain anonymous as 'attaching one's name to a work was considered an egoistical act'. According to the Buddhist doctrine it was expected of him that he should destroy the ego and erase from his creation every imprint of his timebound self. The earliest list of artists who worked at the temple of Samye is recorded in *The Key to the Ocean of Description of Samye*. There we come across the name Rinchen Ozer, who was the chief painter and on him was bestowed the rank of a government official. Painters of icons were called 'Divine Artists' and the long list of artisans also included the names of calligraphers, silver- and coppersmiths, wood painters, stone carvers and turquoise painters.

Among the numerous artists who flourished in the 15th and 16th centuries, five deserve special mention as they caused the inception of various distinctive styles both of mural and thangka painting. Menthangpa Menla Dondrub, founder of the Menri School, was a student of the otherwise unknown painter, Dopa Tashi Gyelpo. He had connections with the old monastery of Nenying and there he 'copied a masterful Chinese Buddhist scroll painting depicting the Great Deeds of the Buddha'. Historical records attest to his other contributions. Khyentse Chenmo of Gangkar was the founder of the Khyenri idiom and worked in a few important mural projects for the monasteries of Gongkar Dorje Den (south of Lhasa) and Yangpachen (northwest of Lhasa). Tulku Chiu was the founder of the Chinri style. His style had an apparent closeness to the Nevar style. Namkha Tashi was the key artist behind the formation of the Karma Gadri, the court style of the Great Karmapa hierarchs. Karmapa lamas who used to be on the move constantly lived in large tent cities with great pomp. The mobile Karmapa encampments were known as Karma Garchen and thus the style patronised in the encampments was labelled the Karma Gadri style (the style of the Karma encampment). As a child Namkha Tashi was recognised as an emanation of Karmapa Mikyo Dorje who would carry the latter's divine accomplishments in the sphere of image making. In 1568 he completed a version of Menthangpa's scroll depicting the 'Great Deeds of the Buddha'.

Choying Gyatsho of Tsang (active 1640-1662) was the initiator of the New Menri style at Tashilunpo monastery of Shigatse in Tsang Province. He was one of the chief painters invited by the fifth Dalai lama in 1648 to paint the murals in the Potala palace which depicted the spread of Buddhism in Tibet and the lineage of the Dalai lamas. Because of a common geographic origin Choying Gyatsho and the first Panchen Lama had an even closer kinship. Choying Gyatsho before leaving for Lhasa,

Facing page: Tathagata Ratnasambhava. Painted in a style directly derived from Pala painting this mandala represents the eight Bodhisattvas originating in eastern India as a predominant Mahayana cult imagery. Central Tibet, Kadampa Monastery. Thirteenth century. Collection: Los Angeles County Museum of Art.

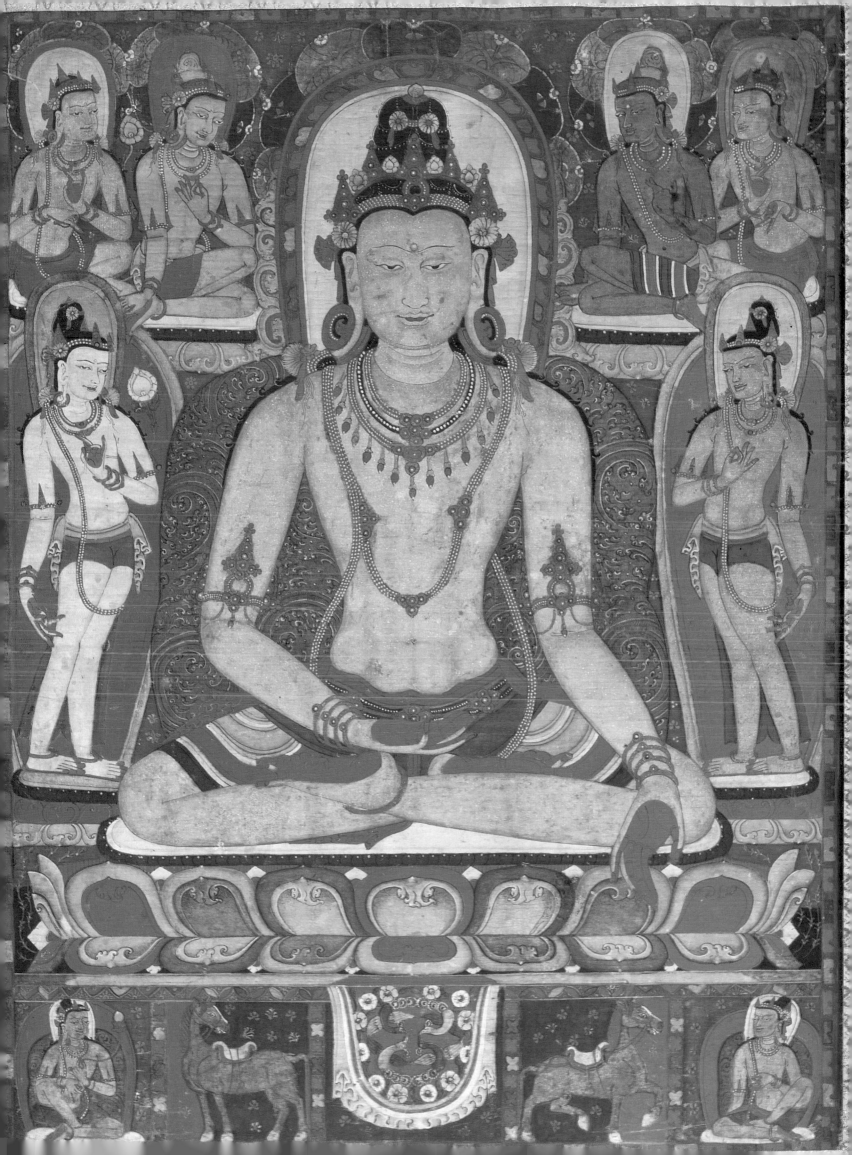

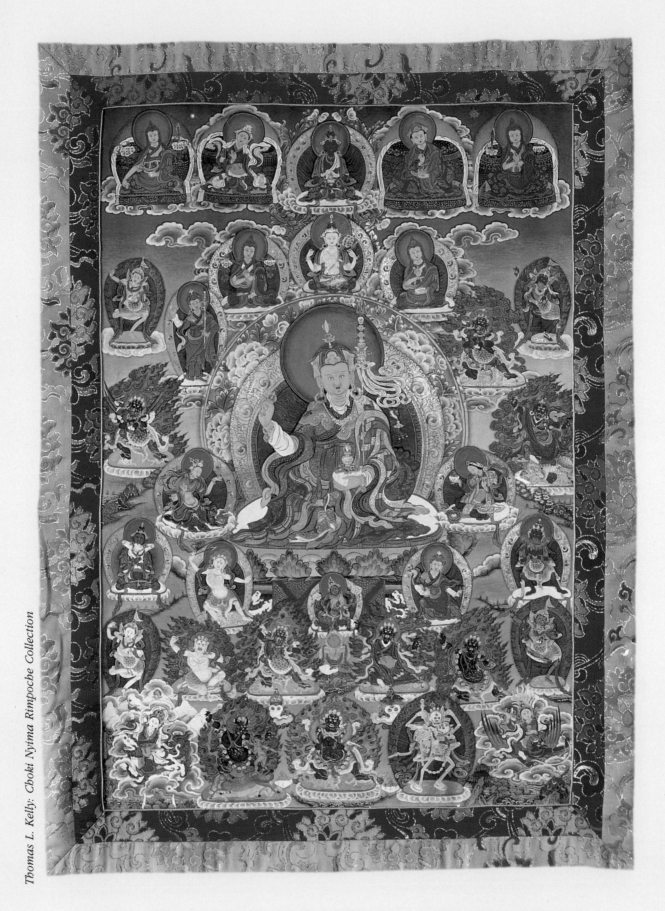

Padmasambhava with adepts and deities of the Nyingma (the earliest tradition of Buddhism) Order. Early 19th century. Considered to be an emanation of Amitabha and Avalotikeshvara, Padmasambhava became a highly popular subject.

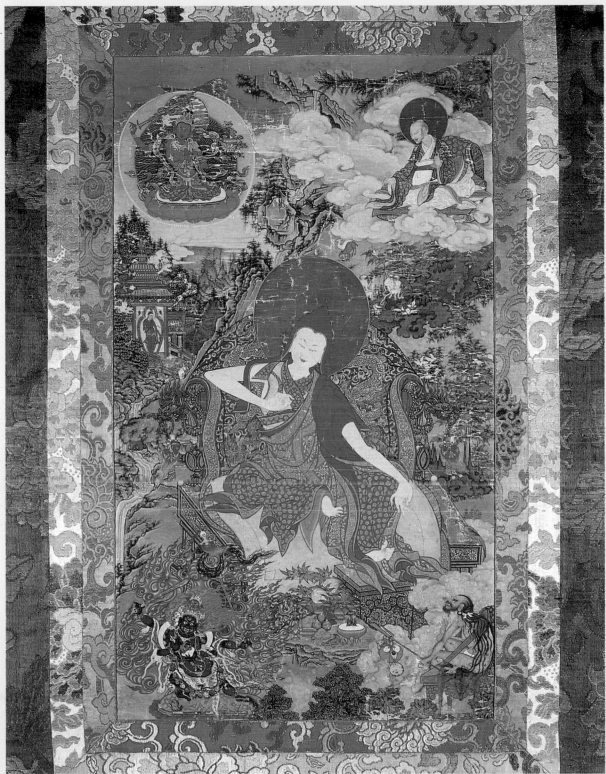

Sakya Pandita (AD1182-1251), the scholarly sage of the Sakya Order. Central Tibet (probably Tsang), mid-18th century. Lama Kunga Gyaltsen, believed to be an incarnation of Bodhisattva Manjushri, the god of wisdom, was popularly known as Sakya Pandita.

painted murals at Wengon and a set of twelve thangkas depicting the Deeds of Buddha Maitreya and the life of Tsong-kha-pa. After his return to Tashilhunpo from Lhasa in 1649 he designed a huge thangka of Maitreya for brocade weaving. Between 1655 and 1662 he completed numerous murals. A golden thangka portraying the first Panchen Lama that has fortunately survived, bears his signature. Details from literature and references in historical accounts, though cryptic, reveal an important fact namely, the ambidexterity of the traditional Tibetan painters. It seems they possessed the great skill necessary to handle the large narrative or iconic themes on the walls of monasteries and temples and at the same time were equally articulate in designing thangkas with minute details.

Nevar artists from Nepal were active from the very early era of Tibet's cultural advancement. It has been rightly suggested that princess Tsezun of Nepal who caused the building of Jokhang, the temple of Buddha Aksobhya at Lhasa in 640 A.D. must have invited skilled craftsmen from her homeland. The commercial relations between Tibet and Nepal developed steadily after the seventh century and remained the prerogative of the Nevars whose language belongs to the Tibeto-Burmese linguistic group. They became especially popular from the thirteenth century and enjoyed the patronage of culture-loving Sakyapas in southern Tibet. The Nevar artist A-ni-ko was then only seventeen year of age but must have been the most talented out of the twenty-four artists Phaspa Lama invited. He later became the 'inspector of artisans' for the imperial atelier of Kublai Khan. There was no convent of Tibet, rightly stated Guisepe Tucci, 'which at the moment of its foundation or its greatest prosperity was not embellished by them with statues or frescoes. From the Saskyapa chronicles to the eulogy of gNasrnin, from the Myan c'un to the abbots' lives, various confirmations can be drawn to the uninterrupted flow into Tibet of Nepalese artists and craftsmen.' As has been mentioned in the autobiography of Taranath, at the end of their commissioned work they received not the price but rewards of various kinds like Chinese cloths, turquoises, gold dust, etc. which could be easily converted into ready money. The paintings of Vanguli and his five colleagues at the Nor monastery (founded in 1422) is confirmed in the chronicles. By the seventeenth century Buddhism already started declining and the monasteries of Patan and Kathmandu ceased to flourish as seats of learning. Buddhism in Tibet on the other hand was flourishing in the epoch of the Dalai Lamas and the growing demand for skilled Nevari artists continued. Interestingly, some Nevar merchants brought back from the land of the snows, consecrated thangkas which were thematically Nepalese but stylistically Tibetan. Such examples nevertheless influenced the tradition of Nepalese *paubha* painting.

The intermarriage between Nevars and Tibetans was common, and thus resulted a class of Nevars called *Uray* to which belonged some of the

Facing page: *Great adepts Virupa, Naropa, Saraha and Dombi Heruka. Drenched in placid blue and pastel terre verte this landscapic vision belongs to the fully developed phase of the Karma Gadri style of Eastern Tibet. Eastern Tibet, 18th century. Collection: Museum of Fine Arts, Boston.*

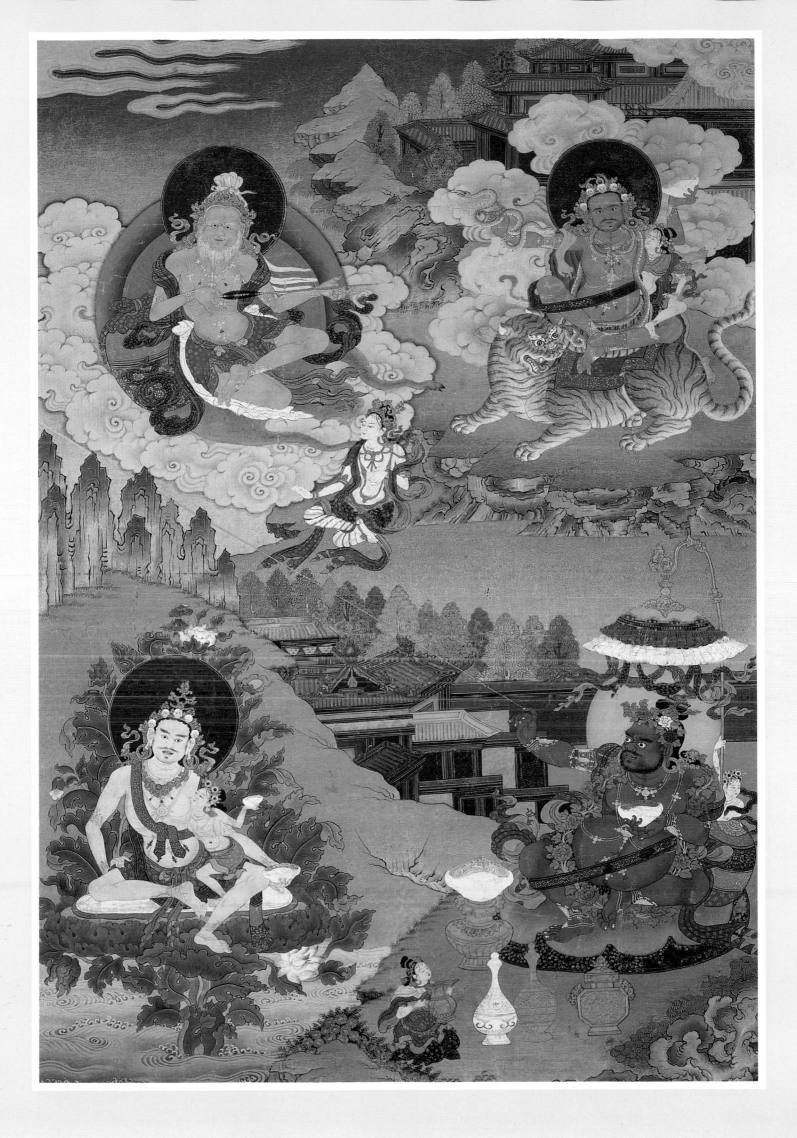

skilled artists working at Khasa, Sigatse and Gyantse. Of great art historical importance are the two surviving pattern books of Nevari artists presently in the Neotia Collection, Calcutta and in the Los Angeles County Museum of Art. These sketchbooks contain carefully done reference drawings of deities, *arhats*, dragons and even of Chinese-inspired landscape elements.

Rinchen Sangpo (958-1055), a disciple of Atisha and known as the Great Translator of Sanskrit Buddhist texts patronised Kashmiri artists during the construction of several monasteries in western Tibet. Kashmiri artists along with Tibetan trainees decorated the temples and monasteries at Ladhak and Guge.

Buton Rinpoche invited artists from China. Chinese painters of the Ming (1368-1644) and Qing (1644-1911) periods were responsible for adding a distinctive idiom to the tradition of thangka painting. During this era were also formed painters' guilds quite similar to those in contemporary China.

The old thangkas were retouched and even parts of them was often repainted . There were no shops selling thangkas or icons in the past and it was held a morally reprehensible act to make money out of the selling of religious works of art. However, placed in a different situation some of the Tibetan painters are now compelled to paint and sell thangkas as consumer goods for the sake of earning a livelihood. Some of the Tibetan painters who left Tibet in 1959 and came to settle down in India and Nepal cater to a different class of collectors and connoisseurs. For the collectors the religious significance of the work is secondary, their primary concern revolves around the antiquity and the formal beauty of a thangka. Thangkas painted in exile are parts of 'the continuum of past and present'. They do not merely 'recall the past as a social cause or aesthetic precedent' but renew the past as 'a contingent in-between space', very truly a part of 'the necessity' and not `the nostalgia of living'. The loving care with which the painters wield the brush and a sustaining concern for the intricate details reflect a conscious reliance in the aphorism of Atisha:

> Wisdom without method
> And method without wisdom
> Remain in bondage
> Therefore, one should abandon neither.

Padmasambhava with consort in the Glorious Copper Mountain Paradise. Early 19th century. The sexual union depiction of Padmasambhava and his consort is indeed a rare subject for thangkas.

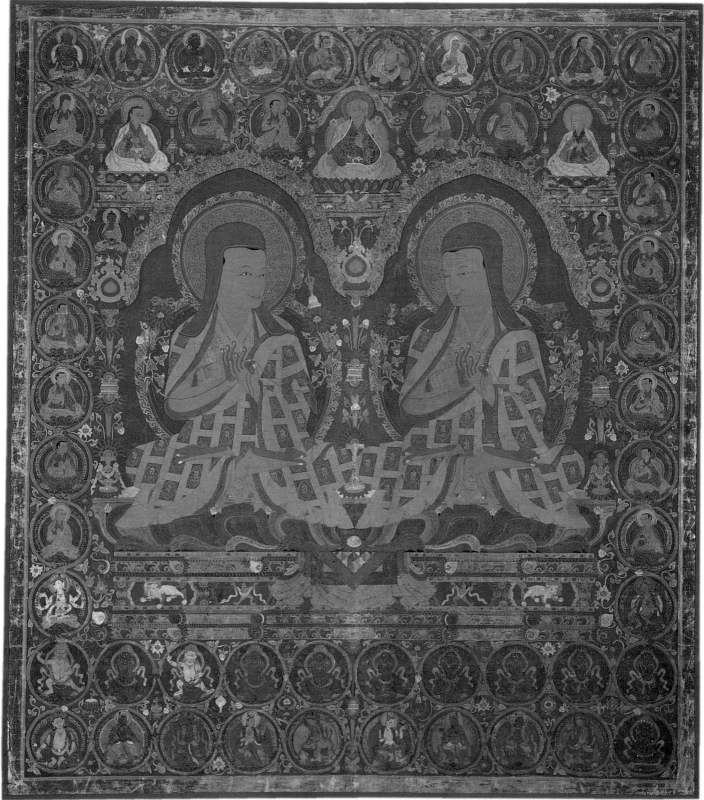

Sakyapa Lineage, Central Tibet. Late 15th century. The two central figures of Lama Kunga Wangchuk (left) and Sonam Senge (right) represent the Tibetan tradition of idealised portraiture.

The Evolution of Style

———————— ✳ ————————

A study of the Tantric Buddhist pantheon, the cult rituals and the iconographic principles of Buddhist painting are indispensable aids to the understanding of the complex religious dimensions of thangka painting. The aesthetic nuances of thangka painting passed through various stages of stylistic development and iconographic speculation. A critical evaluation of the different schools of thangka painting patronised by various lamaist orders is of paramount importance in locating the shifts in the process of painterly expression and iconographic conceptualisation. Many of the regional distinctions in thangka painting resulted from the geographical proximity of the neighbouring countries that made a positive impact on the style. Apart from the Indian, the painting traditions of Nepal, China, Khotan and Persia reached the `Land of Snows', mingled with each other and eventually caused the emergence of a national style.

The earliest known evidences of Tibetan painting on archaeological objects datable to the Neolithic era were unearthed at Changdu. They represent a form of primitive ornamental art which was faintly echoed in the art of later Tibetan nomadic tribes. The first phase in the blossoming of Buddhist art under the overpowering impact of the Indian tradition lasted two centuries, from the seventh to the ninth century A.D. This was the great period of the Yarlung dynasty. Built by King Songsten Gampo, the Jokhang temple (founded in 640) followed the architectural features of the fifth century Buddhist cave shrines of Ajanta in western India. Some of the carved wooden doorways and pillars having vine motifs and figures of flying celestial beings which hark back to the style of the Ajanta caves and to the Nepalese sculpture of the sixth century A.D.

Almost a century later, in the second half of the eighth century, the first Buddhist monastery of Samye was built by king Trisong Detson under the direction of Indian teachers Shantarakshita and Padmasambhava. Though recorded in literature in great detail, very little in the way of painting has survived. However, a few life-size painted stucco portraits of religious kings and their consorts of ninth century A.D., rare examples of royal portraiture in ancient Asian art, show an unmistakable blend of naturalism and symbolism. The Tibetan ecclesiastical community in this early phase of Buddhism was keen to assimilate all the iconographical and iconometric principles of Indian origin. At the same time the techniques suitable for fashioning the icons and painted images were also introduced by the Indian colleagues to the freshly-initiated Tibetan Buddhists.

In order to ascertain the probable nature of Tibetan painting in the eighth and ninth centuries one is tempted to consider the paintings of Tun Huang, the most important monastery situated on the Central Asian Silk Route in northwest China. Tun Huang or the Caves of a Thousand Buddhas was, for several centuries, a great centre of Buddhist art and religion: and the long-buried

library was a treasure-house of early Buddhistic and Asiatic literature. Situated in the cliffs of a river valley, on the edge of the sandy desert of Taklamakan in north eastern Kansu, the earliest of these rock-hewn shrines date back to the fourth century A.D. The majority of the shrines which were dug out and painted by the monks and paid for by the wealthy merchants belong to a longer phase between the seventh and the thirteenth centuries. The wall paintings of Tun Huang, depicting secular as well as religious scenes are still in a satisfactory state of preservation, better indeed than those at Ajanta. Some of the banner paintings (done around the ninth century) executed on silk have also been found in the caves and they were meant for display in these temples or were carried in processions. A few of them bear Tibetan inscriptions and are in a Indo-Nepalese-Tibetan style. The delicate features of the Buddhas and the Bodhisattvas were rendered with a striking linear severity disclosing a clear kinship with the style of contemporary Indian painting. Lithe proportions of the fully revealed body, heavily outlined eyes with intense outward gaze and brightly coloured textile designs are features distinctly non-Chinese and closer to the idiom of the Tibetan painting of the centuries to follow. The palette consisted of malachite green, dull pink, pale blue, white and black with a predominance of red. The finds further reveal that designs were transferred on the walls and cloth supports from pricked cartoons, a device which must have facilitated the execution of carefully-measured iconographical compositions. Scholars claim that Indian artists were present in Tibet during the Yarlung dynasty and their colleagues were Nevars and Chinese.

Tibetans conquered Tun Huang in 759 A.D. and occupied the strategic oasis till 848 A.D. They used it as a base first during the wars waged against eastern Turks and later when they attacked the Chinese posted on the northern and southern borders of Tien-Shan. In the eighth century Tibet became a dominant power in the east holding much of Kansu and the territory stretching into central China. The decline set in with the Yarlung dynasty around 836 and for a period of seven decades there continued in Central Tibet the unsparing persecution of Buddhism. Monks fled to the remote parts of eastern Tibet to keep alive the teachings and ritual practices. A branch of the Yarlung royal family struck tents at the Ngari region in Western Tibet. The new dynasty came to be known as Guge and its rulers were generous patrons during the reanimation of Buddhism and its sacred art under the impact of the Second Transmission, beginning in 1042 with the arrival of Atisha in Western Tibet. On his arrival Atisha, the chief abbot of the Vikramashila Mahavihara in eastern India, was greeted with many gifts including a woven thangka of the Eleven-headed Avalokiteshvara. It is also relevant to note that on his way to Tibet he visited Nepal for a brief period and later Tibetan monks made regular visits to Nepali monasteries in search of the sacred texts which were copied by the local scribes and were also illuminated in a transplanted Pala style.

About the art of eastern Tibet during the Second Transmission nothing is known while the surviving contemporary wall paintings from western Tibet in

Facing page: Mitruk-pa, a meditation and confession deity, surrounded by fourteen deities. Collection: Namgyal Monastery.

Padmasambhava in his heavenly abode, with wives Mandarava and Yeshe Tsogyal, his major twenty-five disciples and archetype deities. Central Tibet, 14th century. One of the earliest known thangkas of this period of Padmasambhava.

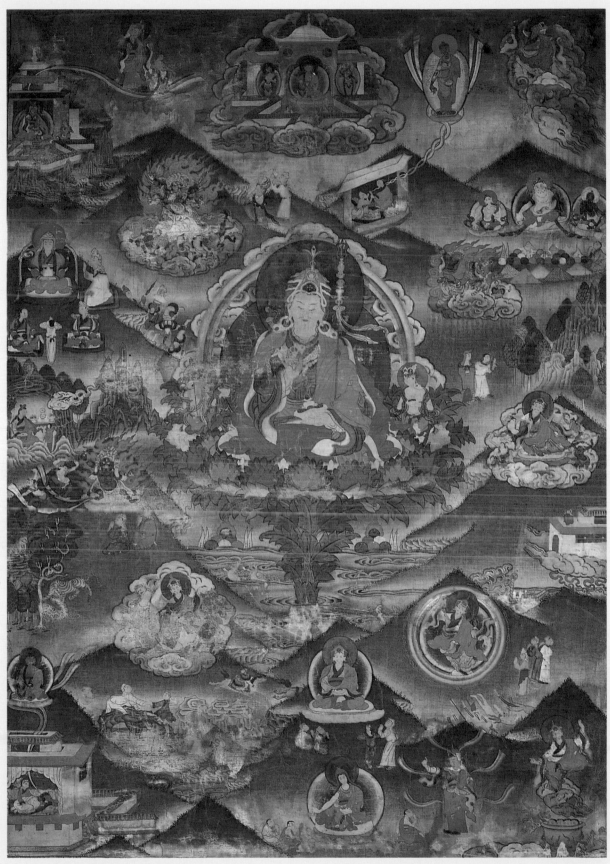

Scenes from Padmasambhava's life. Late 17th century. Padmasambhava appears in a highly stylised floral seat against a landscapic expanse marked with fluid spatial nuances.

which the styles of Kashmir and Central Asia were dominant offer valuable material for an understanding of the roots of the early pictorial tradition. Atisha spent his initial three years in western Tibet preaching to the local people and this created the right religious climate for the great revival of Buddhism. Rinchen Sangpo who visited India twice further strengthened the restoration of the faith. He invited some thirty-two skilled artisans from Kashmir to work on the building projects of temples and monasteries in western Tibet. The most important of such sacred buildings at Tabo, Alchi, Sumstek and Mangnang have wall paintings in the interior. One can notice in the style, two major strands namely, Kashmiri and Khotanese (Central Asian) painting. Chronologically, the earliest datable murals are those of Mangnang whereas those belonging to Tabo are placed around 1042. The figural style is strongly linear with emphasised modelling. The faces, a little plump, are round with lips fashioned in a smiling gesture. Such exceptionally expressive vigour is closer to the style of Khotanese painting. Chronicles record the presence of Khotanese painters and monk-translators in Tibet as early as the first half of the ninth century. The murals at Mangnang and Alchi represent the impact of Kashmir painting, the extreme northern projection of the medieval pictorial ethos of India which had its sources in the great cycles of wall paintings at Ajanta. Notable for warmth and naturalism, the Kashmir style always succeeded in enhancing the superhuman essence of images and qualified the softly contoured features with subtle yet precise details.

The establishment of the first Kadampa monastery in 1054 was followed by the foundation of the monasteries of the other Lamaist orders in the central regions of Tibet. These monastic-cum-educational centres had links with the great Buddhist monasteries of eastern India namely, Nalanda, Vikramshila and Uddantapuri, Vikrampura, Sompura and Tamralipti, as well as with those of Nepal. There were trade routes linking Central Tibet with Nepal and Eastern India which acted as channels for cultural exchange. Scholars as well as devout merchants carried with them illustrated manuscripts studded with gem-like illuminations, painted banners and miniature bronzes. These belonged to the reignal years of the Pala kings (800-1200 A.D.) As a natural consequence the Pala Style and its transplanted version of Nepal served as the dominant aesthetic inspiration for the art of central Tibet.

A group of thangkas painted in central Tibet which may be dated between the 12th and the early 13th centuries represent the overwhelming impact of the art of the Palas at this stage. These thangkas share some of the iconographic elements and painterly nuances with the contemporary wall paints of Jokhang (Lhasa), Iwang, Samada, Nethang, Nenying and Chasa. Since all these establishments were related to the Kadampa order, many scholars prefer to designate the style of these murals as well as of thangkas after the name of the sect.

Facing page: An Arhat with attendants, in the tradition of Chinese Arhat painting during the Song and Yuan period. The row of 129 tiny seated Buddhas on the red border symbolise the notion of a thousand Buddhas. Central Tibet, 14th century. Collection: Los Angeles County Museum of Art.

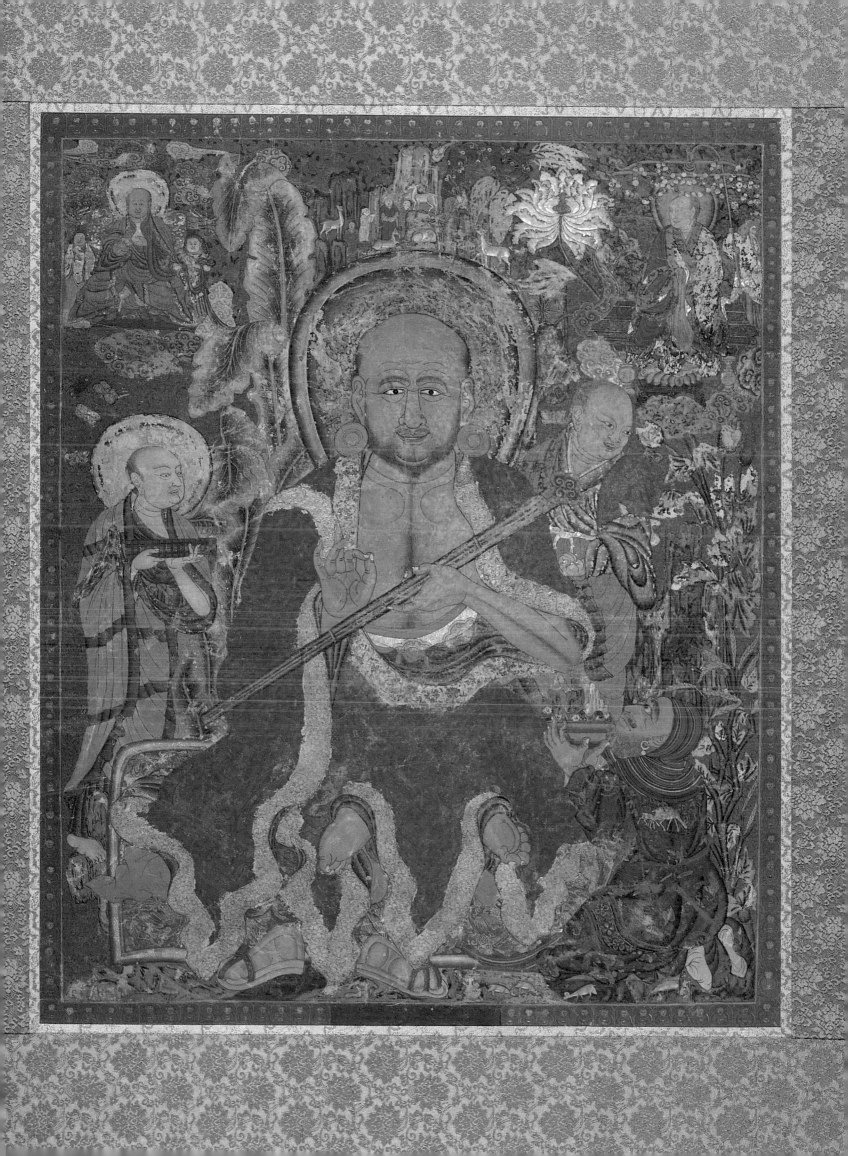

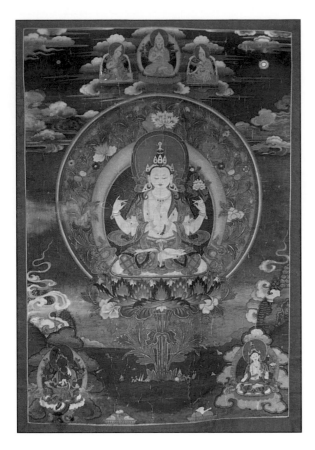

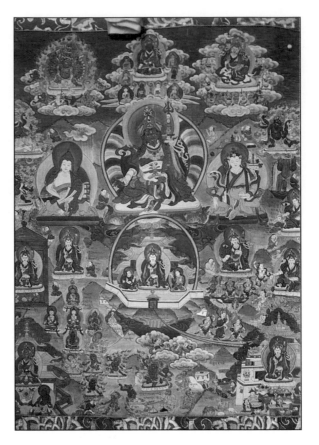

1. Four-armed Avalokiteshvara.

2. The glorious deeds of Guru Padmasambhava.

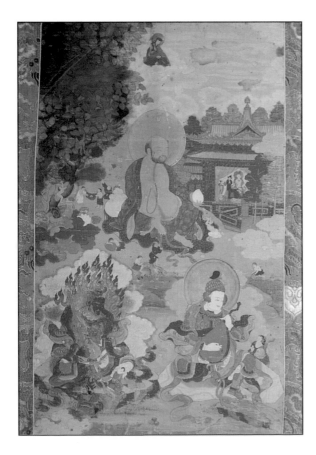

3. Lama with his deity.

4. Sthavira (patriarch) Nagasena.

Antique thangkas (1-5) dating from the early 19th century, donated by **His Holiness the Dalai Lama** to the Tibetan Library of Works and Archives in Dharamsala. Paintings from Tibet of the 19th century and after show a more refined senstivity to realistic detail, as well as the appearance of landscape in a panoramic view or grand vista, incorporating many scenes or elements on the same canvas. The painter achieves a harmonious perfection in integrating the realistic details of the phenomenal world with the idyllic beauty of a deity's transcendent realm.

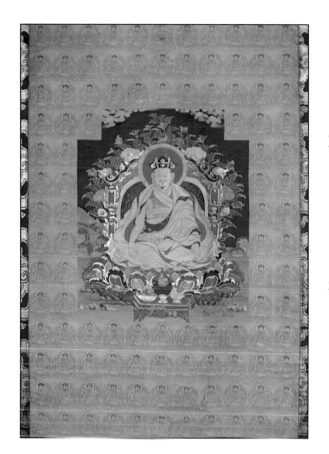

*

5. *Golden thangka* (gser-t'ang) *with a polychrome area depicting His Holiness the II Karmapa*

The title page of a 16th century imperial manuscript of the Tibetan collection of mantras.

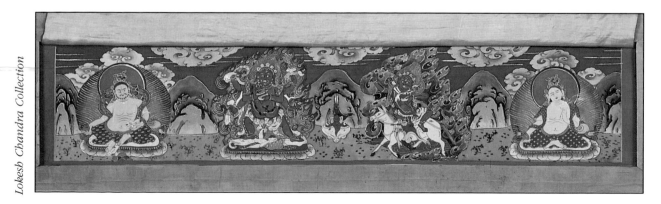

Wooden cover of a 16th century imperial manuscript of the Tibetan collection of mantras with protective deities depicted on it.

In the seventeenth century Tibet entered into the great era of Dalai Lamas who reigned as powerful political leaders patronising various religious art forms. It is in this very century that one notes a steady crystallisation of a national Tibetan style of art. Characterised by stylised realism this idiom was crafted to match the ritual-inspired evocations of the divine and super-human phenomena. Its character soon became an international one and though rooted in Tibetan Buddhist spiritualism it spread throughout the northern Buddhist world and produced masterpieces of Asian Buddhist art.

The full flowering of this new style took place in the mid-seventeenth century. The firm line, thick and even, stresses the articulated contour of the figures. Highly stylised figural imagery rich in rhythmic sway and placed against a fully developed landscapic backdrop, interspersed with foliage and flowers of Chinese inspiration, are some of the chief hallmarks of this period. The traditional Indo-Nepalese style with its characteristic niche shrine formulation and rigidly compartmentalised compositions gave way to an overwhelming spatial expanse. Composition marked with asymmetrical balance was indeed an innovation. The deities seated on cushioned thrones or standing in an exalted stance on their prescribed vehicles seem to float in an ethereal zone, amidst clusters of clouds or bunched up tongues of flames. The special genre of black thangkas (Nag than) which had its inception late in this century demanded great artistic dexterity as every line that was once drawn had to be final and could not be erased or corrected. Figurative details in these highly mystical black thangkas with emphasised plasticity of limbs slowly reveal themselves through translucent touches of colour and gold.

Increased homogeneity and even a good deal of affected addiction to a distinctive manner noticeable in the eighteenth century styles of thangka painting was inevitable in an era of unified rule by the Dalai Lamas. Added with exceptional care the gold brocade patterns on the drapery, crisp tonal gradations of the flower petals in bloom and the painstakingly intertwined jewellery comprising pearls and precious gems increased the decorative spirit of the thangkas. An ecstatically religious mood encompassed the entire pictorial structure ensuing from the self-conscious virtuosity and the painters', delight in decorative extravaganza. A freshly introduced motif was the depiction of architectural landmarks like shrines and palaces represented in a bird's eye-view perspective. Some of the big sized thangkas depicting monasteries and the Potala Palace of Lhasa or the mythical kingdom of Sambhala are both thematically and iconographically significant. The painters tried to transform various specific aspects of the holy places and presented them as images bestowed with a timeless identity.

Previous pages 92-93: The temples and monasteries of Lhasa. Eastern Tibet, first half of the 19th century. The Great Potala Palace of the Dalai Lamas and the three main monasteries of the Gelukpa order, namely, Drepung, Sera and Ganden. Depicted below is the Dalai Lama on a white horse proceeding from the compound of the Jokhang temple. Collection: Thomas L. Kelly/the George Crofts Collection, Royal Ontario Museum.
Facing page: Thousand Buddhas, Ajanta, Cave 2, tempera painting on wall. Sixth century. The mural illustrates the Miracle of Sravasti when Buddha multiplied himself a thousand times, leaving his critics awe-struck. This event consequently served as the basis for iconographic elaboration in thangkas symbolising the notion of Thousand Buddhas.

Further Reading

B. Bhattacharya, *The Indian Buddhist Iconography* (Oxford, 1924)

David P. Jackson and J.A. Jackson, *Tibetan Thangka Painting: Methods and Material* (London, 1984)

G. Tucci, *Tibetan Painted Scrolls* (Rome, 1949)

H. A. Giles, *Introduction to the History of Chinese Pictorial Art* (Shanghai, 1918)

J. C. Singer and P. Denwood, *Tibetan Art. Towards a Definition of Style* (London, 1997)

Lokesh Chandra, *Iconography of the Thousand Buddhas* (New Delhi, 1996)

Lokesh Chandra, *Transcendental Art of Tibet* (New Delhi, 1996)

M. M. Rhie and R. A. F. Thurman, *Wisdom and Compassion. The Sacred Art of Tibet* (New York, 1991)

Philip Rawson, *Sacred Tibet* (London, 1991)

Pia and Louis van der Wee, *A Tale of Thangkas* (Antwerp, 1995)

Pratapaditya Pal, *Tibetan Painting* (Basel, 1984)

The Art of Tibet (Los Angeles, 1990)

Acknowledgements

I wish to acknowledge with gratitude the assistance of the following persons and institutes without whose cooperation this book would not have been possible: Tenzin Chogyal Sangye, M. A. Dhaky, Lokesh Chandra, Thomas L. Kelly, Ian Baker, Mr & Mrs John Gilmore Ford, Joachim Baader, T. K. Biswas, Gyatso Tshering, Jampa Sampten, Yuku Tanaka, Kim Yeshi, Jeremy Russell, Gyaltsen Tsering, Pramod and Kiran Kapoor, Ashok and Jayashree Kapoor, Gautam and Suchitra Chakraverty, Bela Butalia, James Giambronie

INSTITUTES: Private Office of H. H. the Dalai Lama, Namgyal Monastery, Norbulingka Institute, and Library of Works and Archives, all from Dharamsala, India; Victoria & Albert Museum, London; Musée Guimet, Paris; the Newark Museum, New Jersey; Museum of Fine Arts, Boston; Zimmerman Family Collection; Arnold Lieberman Gallery; Choki Nyima Rimpoche Collection; Medical Institute of Lhasa; Perrin Lieberman Galleries; George Crofts Collection, Royal Ontario Museum, Toronto; Los Angeles County Museum of Art, USA.